MARKINGS

AERIAL VIEWS OF SACRED LANDSCAPES

Photographs by
MARILYN BRIDGES

Preface by
HAVEN O'MORE

Essays by
MARIA REICHE
CHARLES GALLENKAMP
LUCY LIPPARD
KEITH CRITCHLOW

Afterword by
MARILYN BRIDGES

APERTURE _____

A ∀ SADEV BOOK

To those who have seen and to those who are seeking

ACKNOWLEDGMENTS

To the bush pilots who directed me over jungles, deserts, and mountains.

To my family and extended family of friends and teachers who encourage my work.

To the museum directors, critics, curators, and collectors who have helped keep my artistic spirit alive in relative comfort.

To the Guggenheim Foundation, the National Endowment for the Arts, and the New York Council for the Creative Arts for their support in making portions of this work possible.

To Will Roger Peterson and Felicia C. Murray for their support throughout my career.

A special thanks to those with whom I worked closely on this book: Thomas Bridges, Mark Holborn, and John Macone.

And to the Ancients whose spiritual motivation, artistic vision, and intensive labor caused these markings on the sacred landscape.

CONTENTS

PREFACE

The photographs in *Markings* show for all to see that structures from our past speak meaningfully to us here and now. Being the photographer she is, Marilyn Bridges had to discover this for herself. Flying over the ancient structures she experienced change as a process, not merely as an event: she saw past as present, present as past and was able to capture in her photographs a view into that mysterious something we call the future. By studying Bridges' photographs, the photographs she literally risked life and limb to make, we realign ourselves with change-as-process: we are transported into the future while apparently looking at the past from the present.

With her camera airborne Bridges transposes temporal daily vision. We see her images from priviledged status, from the point of view of the Gods, so to speak. Because clearly, as these photographs show, the structures were intended by their makers to be seen and experienced *sub specie aeternitatis* (under the aspect of eternity). The makers of these structures saw the earth's landscapes as a harmony integral with the cosmos; they located within themselves a point corresponding to this harmony. The monumental quality of the structures shows that the internal point was extended through architecture to universal coordinates. We are still discovering these coordinates which are rooted within all human beings and which, when located and experienced, redeem man's inwardness. The individual making such discovery is no longer a stranger to himself or herself nor alone in the cosmos losing potential through bewilderment and fear. Bridges' photographs go far toward showing the identical harmony existing within the human body, but extending through human uniqueness, to encompass the landscape itself.

To begin to realize the harmony existing between the inward and the outward—what does this mean? Can it mean anything less than to enter into the Presence of the sacred, to begin the necessary movements towards awareness of It?

Marilyn Bridges' work shows she understands this. Her work seizes and shows she was seized: she was commanded at her deepest level, far down in her intuitive awareness, to photograph what you see in *Markings*. Hers is and has been a sacred journey. For to make her photographs she has had to go through her personality, her presence to come into the Presence, a sacred journey for all who enter it. In this process, *there*, she began her discovery of that Presence all humans at all times, knowingly or unknowingly, seek in the very presence of living.

All who view these photographs with deepening urgency participate, each for himself or herself in varying measure, with Bridges and the makers of these ancient structures: the sacred journey in the last analysis becomes one's own journey.

As is fitting in such a work a number of elements come together in higher synthesis—elements from the past through the ancient peoples who made the structures photographed in *Markings*, and elements from the present including the photographer and others involved in making this book. The book thus serves two purposes in its unity: a) it preserves for the future a unique view of precious works of the past, works under siege and being destroyed by the modern world; b) it aids those living in the present by linking the present more deeply and accurately to the past. Counterpointing the photographs and to root them even more firmly in the soil of the present, four short essays are presented.

Maria Reiche, who began studying the Nazca lines in the early 1940s, speaks of the earth "drawings" and admits perplexity as to the reason(s) the drawings were made. She discusses certain astronomical relationships but acknowledges that this is speculation. She feels that to understand the how and why of the drawings' scales will open "the mental processes of the mysterious race" behind this work. Discussing how the drawings were made, Reiche points out the wide-ranging consistency of using the human body to determine measuring units. (Later Keith Critchlow independently elaborates man measured and measuring.)

Charles Gallenkamp presents a brief overview of the Maya civilization. He appropriately quotes Sylvanus G. Morley's opinion (Morley made outstanding linguistic and historical contributions to Maya studies earlier in this century) that the Maya were "the Greeks of the New World." That the Greeks were not the Maya of the Old World (except in exceptional individual cases) is equally true, for the Maya were possessed with a passion for the sacred

which is perhaps equaled among ancient peoples only by the Vedic Āryans and the Egyptians—especially in the earlier dynasties.

Lucy Lippard dwells on time revolving to space in the photographs grouped around the American landscape. It is of course interesting to contemplate the time-to-space interaction. For viewed *sub specie aeternitatis* there is only space or, rather, the appearance of space. But viewed *sub specie temporalia* (under the aspect of temporality) time becomes dominate, the drawings, the architecture, the monuments predominately changing and being changed. One is never certain that one is seeing *what* one is seeing: functions and relations are concealed, and the mystery intensifies.

Keith Critchlow discusses sites in Britain and Brittany. Fundamental to his discussion is the increasing evidence that the ancients lived at a level of *memory* virtually unknown to modern man. In fact of function, modern man is most characterized by *loss* of memory excused as "forgetfulness." Three kinds of forgetfulness can be identified: of the past, of the present, of the future, all bound up with time. Memory being purely spatial shares with photography domination over time. Photography ruptures time but remains subordinate to memory to have identity. In a certain respect photography aligns itself to space, but in the end to have existence it must subordinate itself and become the willing disciple of Memory.

From the Gods/Angels' view photographic testimony in *Markings* we see architectural structures determined by the human body (time) interconnecting with geometry (space) and defined by position (memory). As *Markings* provides at another witness-level, "certain ideas and concepts are ultimate for man." This throws light on modern man's dilemma: failure to accept *the ultimate* both within oneself and the cosmos—to accept it, verify it, and act on it.

The structures in *Markings* show one thing most clearly of all—that earth and man are of the same essence. The structures thus function as signs. Man arises from earth; man returns to the earth's dust. Earth's great temple is man. Man contemplating, as Critchlow points out, brings time (Latin, *tempus*) and space (*templum*) together in the temple—man's act of contemplation within his own human body. But to truly activate his contemplation man requires alignment with earth and the heavens (the external arising aligning with his own most inwardness), surely the higher purpose of the structures photographed in *Markings*.

Were not the structures Marilyn Bridges has intelligently and devotedly photographed of *use* to their makers on many levels? Could they not perhaps have been of most use as a ladder to the ultimate? Does not modern man's discovery, on entering into these structures *sub specie aeternitatis*, open up the possibility of a new and more interior discovery in this time? Can the past be more usefully employed than as a guide and sign by which, standing in the present, we look into the future? For as Hölderlin has written in one of his great poems, "Long is/The Time, its passing brings but/The Truth." Is *the truth*, future as well as present, past as well as future not always *there*, where man stands? And if it is not, how can it be *the truth*?

Photographs such as these in *Markings* affirm for modern man what ancient societies knew and demonstrated—*man is the measure of the universe.* With his new art of photography and the signs it creates, and his comparatively recent science and technology, modern man is further confirming that the *signs of the universe are the measure of man.*

HAVEN O'MORE

NAZCA LINES, PERU

Traveling by air over the tablelands in the vicinity of Nazca, a small town in southern Peru, one experiences a tremendous surprise. Here and there on extensive waste plains, which stretch in majestic loneliness from the foot of the Andes toward the sea, appear strange manmade shapes. They look as if they were traced by giants with kilometric rulers. The viewer has been given the privilege of seeing a unique monument that was intended to record important knowledge for posterity.

Approaching Nazca from the north on the Pan-American Highway, one would not imagine that this immense desert vibrates with a secret life impregnated by the concentrated efforts of many generations through thousands of years. Over the centuries, travelers on donkeys and mules who crossed in different places on their way from one valley to the other did not realize that they violated a most original and mysterious monument written by wise men who guided the destinies of a great nation. This document is difficult to read. Its letters are gigantic, perhaps to make them illegible to the uninitiated. Some parts of it have been decoded, others will be read in the future, and some will perhaps never be explained. In this respect, we are still in elementary school learning how to read.

To see some of the details it is necessary to fly high above the desert. From this advantage appear immense drawings forming triangles and quadrangles, often superimposed. Their lengths reach hundreds of meters, and the largest is about 1,600 meters (almost a mile) long. There are also small drawings a few meters long, which can only be viewed at an altitude of 300 feet. Others must be seen from the ground or a ladder. Long straight lines with neatly outlined borders, also in a great variety of widths and lengths, connect triangles and quadrangles. Two of them are over nine kilometers long and absolutely straight. Sometimes the lines are centered like sun rays or run in groups in almost parallel directions.

Inserted here and there in this network of geometric markings are the most spectacular figures—birds, felines, reptiles, and other animals, flowers, and abstract shapes like spirals and spiraling labyrinths. The figures are four meters to three hundred meters long. From the air, their winding lines show a perfect and harmonious distribution in space, although none of the figures contain symmetrical features.

This region may have been chosen for drawing because of the color contrast between the surface and the interior of the soil. From the Andes an alluvial mass consisting of clay and big boulders had come down and filled an immense basin. The boulders split into small fragments because of extreme temperature differences between day and night and the clay between them was removed by strong winds. The remaining smallish stones are rather heavy, containing iron that has become oxidized. Thus the whole region—mountains and plains—has the brown color of rust. It was easy to produce a surface for the markings by pushing the stones aside and uncovering the yellowish white clay beneath. Most lines of the markings are furrows several feet deep to only a few inches deep.

The number of drawings is immense. From the air one generally sees only the areas of greatest density and size of drawings. There are dozens of figures, hundreds of triangles and quadrangles, and thousands of straight lines. The greatest concentration is at the edges of each tableland where the people climbed to from the valleys to begin their drawings. From the air one also sees isolated triangles and long straight lines in the midst of the desert. Other figures are on high mountain tops or behind mountain ranges—locations to which people had to walk for hours before they could start drawing. Why they did so is quite difficult to explain. It is also still unexplained why they wanted to draw on such different scales. Once we can answer these questions we will have penetrated deeply into the mental processes of this mysterious race of artists.

WHO AND WHY THEY MADE THE DRAWINGS

We know little about the people who created the drawings. We call them Nazcas, but we do not know what they called themselves. The period of their culture dates from about 400 B.C. to A.D. 800. They were a sedentary, agricultural-based people who lived in the river valleys that cut through the lifeless desert of the coast. They created brilliant polychrome pottery and exquisite textiles with motifs depicting a host of major and minor gods, and they probably practiced ceremonies that stressed fertility and the propagation of agriculture. They looked to the sky for signals marking the return of water to dry rivers and the time to plant their crops. And they appealed to the gods above when nature appeared to be out of line.

There are many theories about why the lines were made, but most are based on insufficient evidence. The only thing that can be considered here are the dimensions, directions, and relative positions of the lines. From their directions we can obtain a possible explanation of the use of the lines. Many straight lines divide the year into four parts, pointing toward the rising and the setting of the sun at the sol-

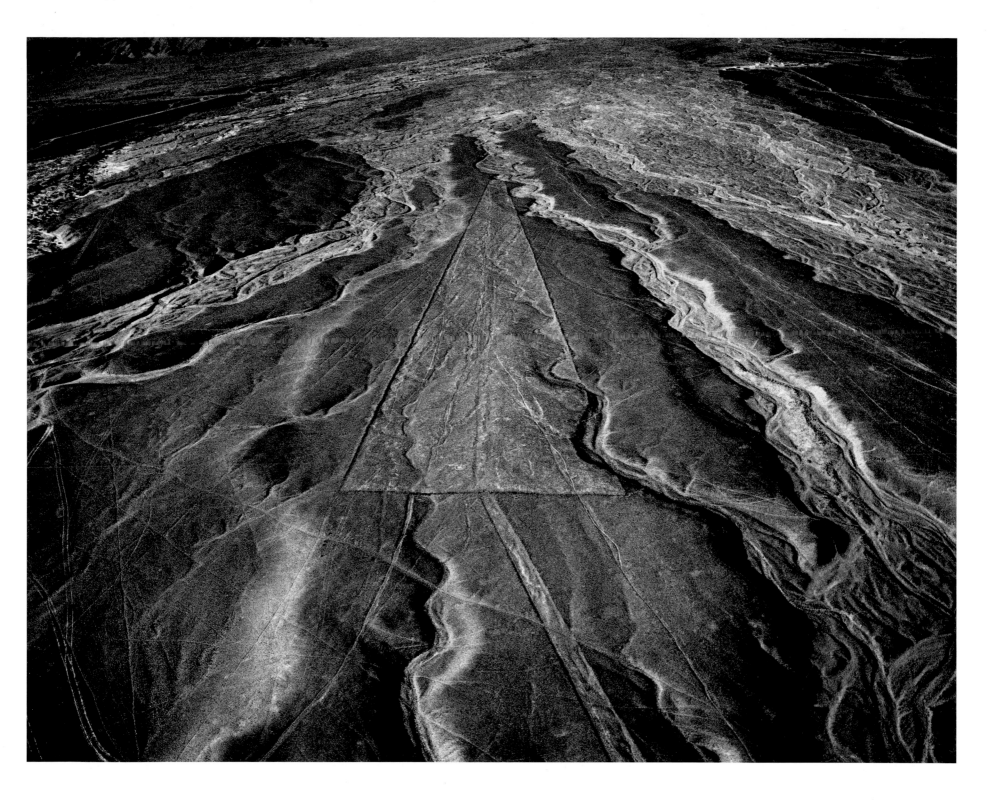

GREAT TRIANGLE, 1979 This one-half-mile figure is bisected at its base by a line
some 16 feet in width. The triangle might have served as a ceremonial gathering place and
the line, a ritual pathway. The terrain shows scars from prehistoric flash floods.

stices and equinoxes. Equinox lines are less frequent than solstice lines and probably represent a later development introduced by the Incas, who we know went to Ecuador to observe the passage of the sun at the two equinoxes.

There is a very important center at Nazca from which twenty-three lines, triangles, and quadrangles radiate in different directions. Connected with this center by a solstice line is a small center that must have been added by the Incas, because it contains a complete sun calendar with another solstice line and two equinox lines. Unfortunately this center was badly damaged in 1955 when the stones were carried away for use in road construction. Instead of a neatly outlined starlike center, there is now only a large white spot and the curving tracks of a truck.

More common than sun directions are moon directions. They refer to a phenomenon that can be compared to the solstices, the points on the horizon where the sun rises and sets at its greatest distance from east and west. The moon also has extreme rising and setting points, the distances of which from east or west are greater than the solstice points.

A very interesting moon direction is that of an immense quadrangle 800 meters long situated beside the figure of a spider. Another big quadrangle a little further north has the same moon direction, but only in one border. The other side swerves off in a solstice direction. This combination would have been used to predict eclipses. The people who directed these activities were a special class who guarded this secret; from their observation of the horizon, they dictated the time for sowing and harvesting and organized the distribution of food over the dry months. To distinguish the seasons they could also have used figures, some of which may represent the constellations.

The most important time of the year was December, when people began to make furrows in the fields for the arrival of the water in the dry rivers. In ancient times in order to know when to begin these preparations, they could have used the same method as in ancient Egypt, where the periodic flooding of the Nile created similar conditions. To be prepared for the flooding in Egypt, astronomers anticipated the appearance of the constellation Canis Major, including the star Sirius, which would not have been seen for many months. In Nazca, the corresponding constellation would be the Big Dipper,

seen upside down in the Southern Hemisphere. When in some years there was less water in the rivers, the frightened people imprinted the image of their water-bringing divinity—the constellation they always saw appearing together with the water—on the ground on such a big scale that the divinity could behold its own image from high up and be induced to bring more water.

The image of the Big Dipper could be the monkey, with the handle of the Dipper represented by the arms of the monkey in a gathering position. Other stars complete the picture. Before air pollution, when the sky at Nazca was especially clear, one could easily recognize the similarity. Another reason the Big Dipper is thought to be the monkey is because the geometric drawings connected with it contain the directions toward the rising and setting of the largest star of the Big Dipper in A.D. 1000. The monkey could also be considered the god of the water because its contour line is continued in a zigzag, a symbol for water.

Another figure that could be a constellation is the spider. Two long straight lines passing through it coincide with parts of its circumference that point to stars in Orion. And the shape of the figure, narrow in the center, is a bit like Orion.

There is also the figure of the hummingbird. In the mountains some people still call a constellation the Hummingbird. When this constellation is properly identified, it should be possible to find a connection with this figure. Hummingbirds come in droves to pollinate maize flowers, and they are also a popular depiction in ancient ceramics. In general, it appears that the people who made the ceramics revered the same creatures as the people who made the figures.

HOW THEY MADE THE DRAWINGS

One especially interesting question is how these people solved the tremendous technical problem of giving the figures their perfect proportions without being able to see them in their entirety. Surveying engineers would agree they could have done this only by enlarging from a smaller chart. The process of enlarging could be imagined as follows. With a piece of cord they doubled the distance; the result was doubled again. Continuing thus they would arrive soon with great accuracy at immense proportions—1:16, 1:32, 1:64, and so on. Most figures consist of such regular curves that they must have been drawn with a stake and a cord as with a large compass. (Cords twenty to thirty meters in length have been found in graves.) The contour

lines use exactly the same geometry as that used today in building curved roads—a succession of segments with different radii adhering to each other at the sides.

From the different radii of these curves the ell—a universal unit of measurement—is extracted, measured with a piece of string held between thumb and forefinger and pulled to the elbow (the "bow" where the "ell" is measured). This unit of measurement, approximately 15 to 16 inches, is still used in small villages in Peru, Argentina, Spain, Romania, Russia, and India. (In medieval Europe, an ell was designated as twice the length of a Roman foot, or 108 centimeters.) Sailors use it when they wind their lines between thumb and forefinger and around the elbow. It was used by the ancient Egyptians and by the Jews, who believed it was used in building Noah's ark. In the megalithic monuments of Great Britain and Carnac in Brittany, a yard was found that is 82.9 centimeters (approximately 2 ells of 41.5 centimeters). In Nazca, the ell is 38 to 40 centimeters, because the people were slightly shorter than their European counterparts.

SOME THEORIES ABOUT THE DRAWINGS

People tend to project their own interests onto these lines. A cartographer sees them as a map of the Lake Titicaca region. A man in public administration sees them as providing work for the unemployed. The devout see religious symbols. Drug addicts see their hallucinations. Joggers see paths for runners. The popular conjecture that the lines are so large because they were made to be seen by people from space is based on incomplete observation. And, of course, the idea that some of the big quadrangles could be airfields used by extraterrestrial beings is simply wrong. Some quadrangles seen from above do look like landing strips, but closer inspection shows that the ground inside their borders is not as flat as it appears from a plane, and the soil is soft clay.

The hillside figure that pilots like to call the astronaut represents a frequent subject in sculptural ceramics, a human figure with an owl's head. The face consists of two big circles for the eyes and a small triangle for the bill. This figure points with one arm up and the other arm down, implying that we should look at the sky and the ground at the same time. Because the owl can turn its head 180 degrees it is thus a symbol for looking at the past and the future as a kind of soothsayer or oracle.

PROTECTING THE DRAWINGS

When the first sensational theories about the connection between the lines and extraterrestrial visitors were proclaimed, arriving tourists damaged figures and lines by walking or driving on them; the spider, the big bird, and some others suffered particularly. At my request, the Institute of Culture hired a guardian and declared the sites an archaeological monument. While I was studying I also helped defend the place by driving away visitors. It was difficult to find appropriate people for this job and guardians had to be changed several times. After a long search I found a reliable person, and then two more, and bought motorcycles for them. To protect the whole area is very difficult. Fencing it would only provoke people to trespass.

Air pollution, which threatens to destroy ancient monuments all over the world, exists here also. The drawings had been preserved from time immemorial because of a special climate. In an ancient geology book one can read that this was the driest place in the world, drier than the Sahara or any other desert. Air pollution has caused climatic changes. When I first started studying in the early 1940s, it rained only half an hour every two years. Now the rain is more frequent, and one does not know what to expect in the future.

Nazca is one of the greatest monuments of ancient man, and the preservation of this site and others throughout the world should be a concern to us all. The future is deeply rooted in the past and the present is a conduit for this linkage. The loss of this irreplaceable art would be a tragic footnote in the history of our times.

MARIA REICHE

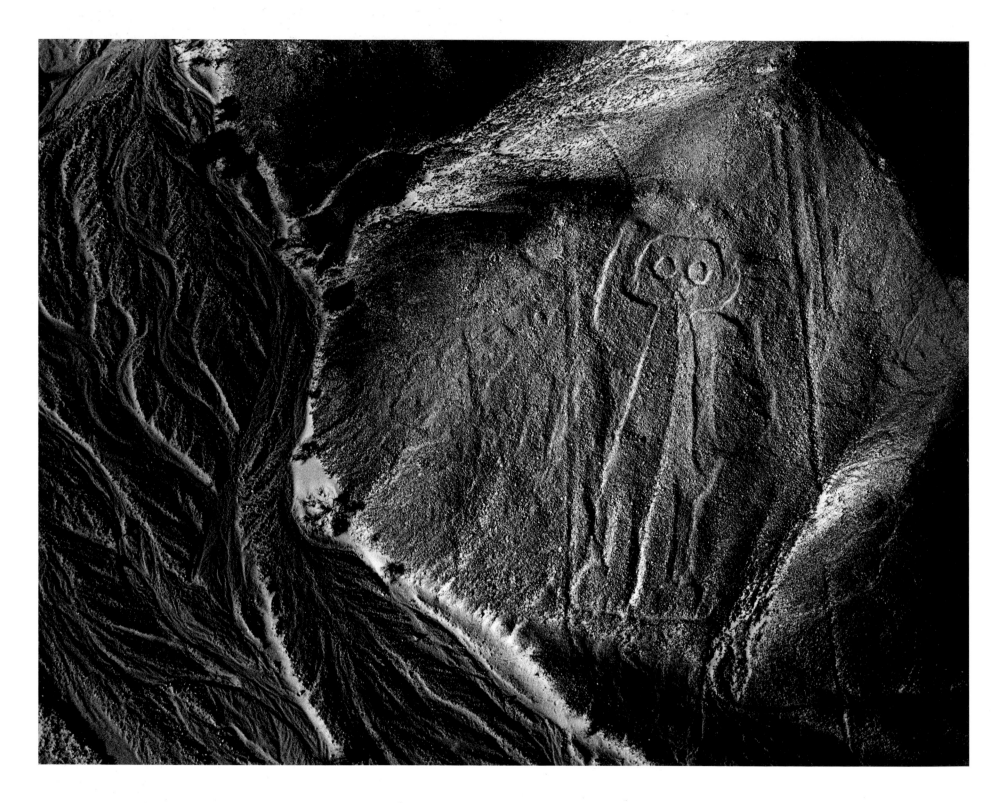

OWL MAN, 1979 A common motif on Nazca pottery, the owl man is probably
a moon deity, and may be a transitional figure between the earlier
Chavin/Paracas culture and the Nazca. The height of the figure is 100 feet.

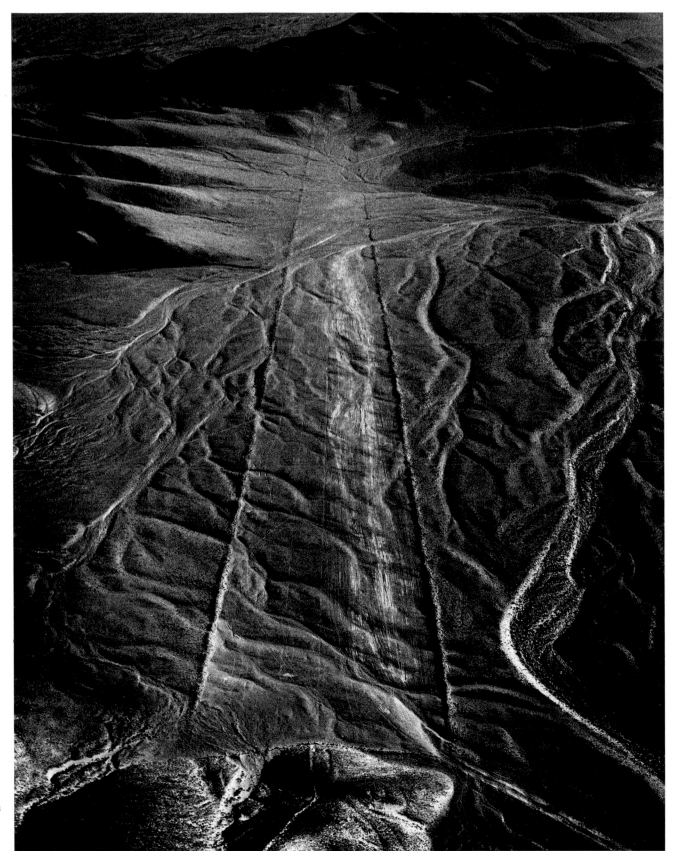

PATHWAY INTO INFINITY, 1979
False trapezoidal figures are common
drawings on the pampa. Two lines, each
three feet in width, appear to converge.
They extend for miles until they are
lost in the foothills of the Andes.

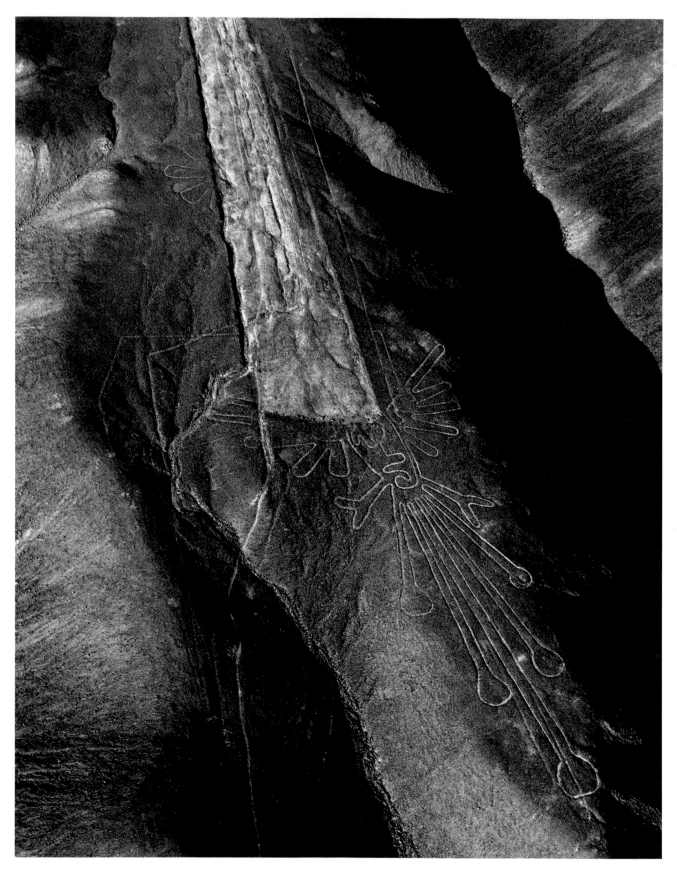

TAIL FEATHERS ON PAMPA, 1979
The upper part of this 300-foot stylized
bird intaglio, with bulbous-ending tail
feathers and forked feet, has been
obliterated by a trapezoidal figure.
A portion of a flower drawing is visible at
14 upper left of the trapezoid.

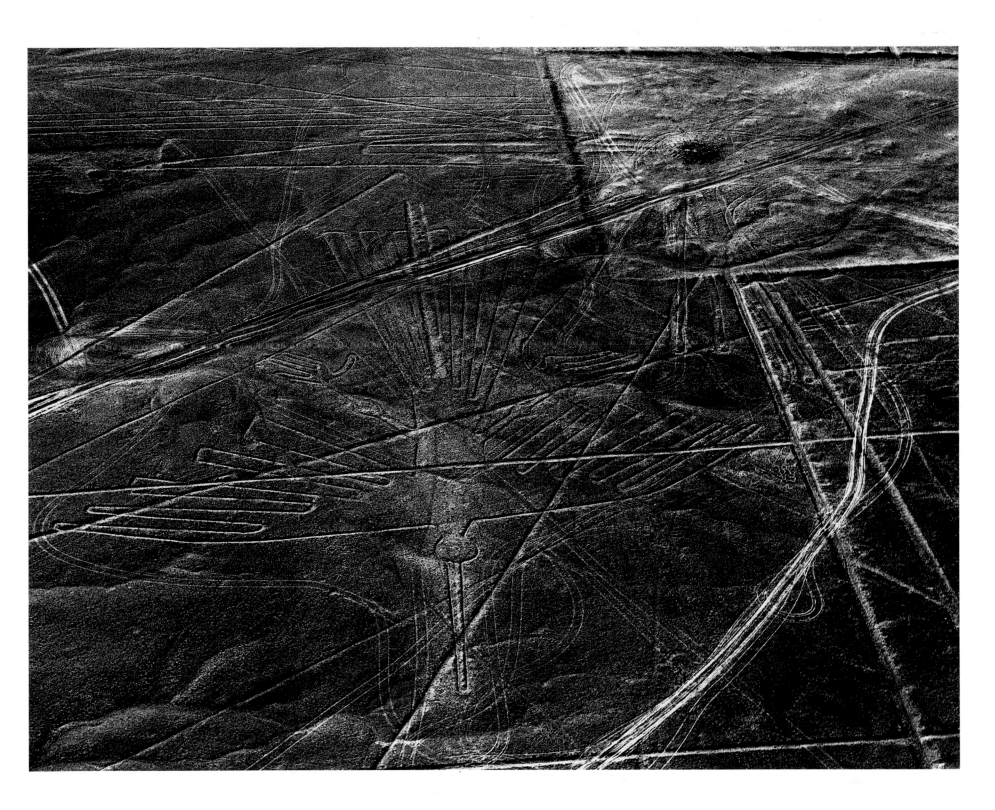

SOLSTICE BIRD, 1979 This bird, with a wingspan of 475 feet, has been criss-crossed
by lines drawn by the ancient Nazcas and almost erased by modern vehicular traffic.
The straight line transversing its wings has been identified as a solstice line. 15

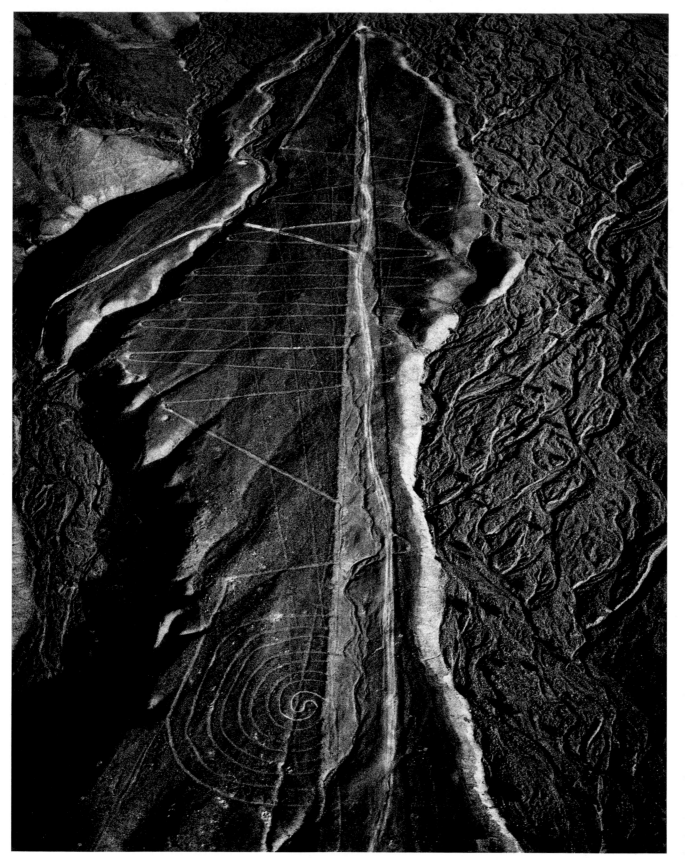

16

YARN & NEEDLE # 1, 1979
The figure's name is a localization.
It reaches nearly 2,800 feet in length and
appears to have been rendered in phases,
beginning with a double spiral to which
was added a zigzag pattern and finally
a tapered trapezoid.

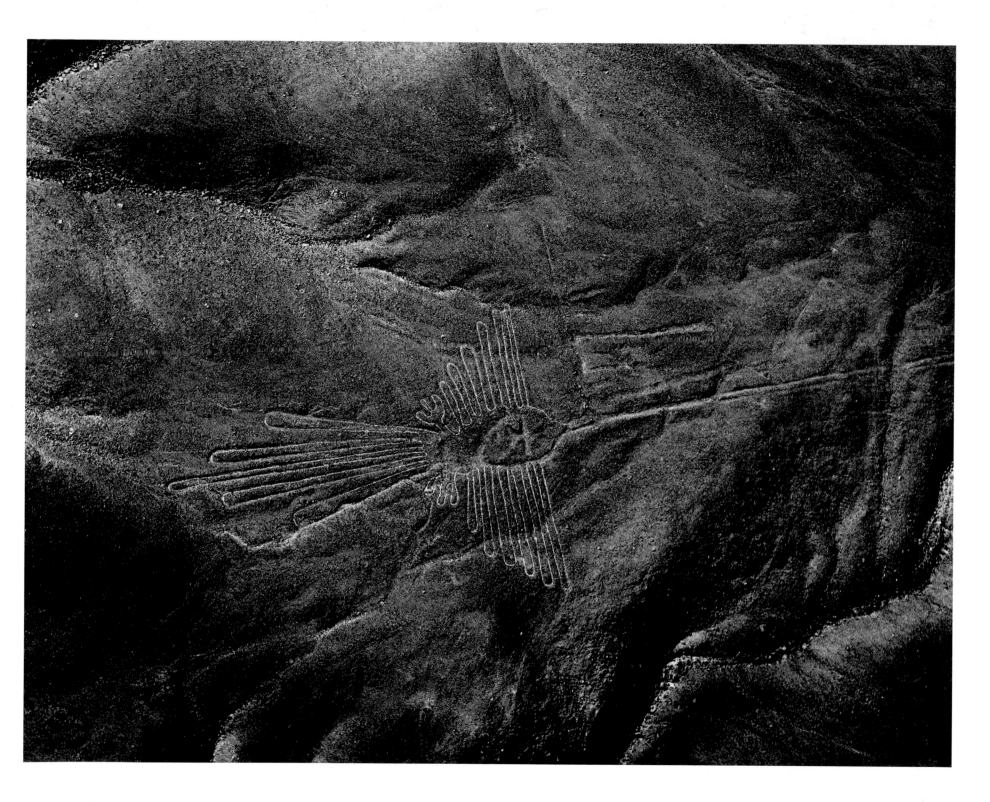

BIRDMAN ON PAMPA, 1979 This 450-foot bird has an extension that was added to the beak at a later date by the Nazcas, giving it the appearance of a hummingbird. Some people see the impression of a face on the creature's back.

LEMNISCATE, 1979 S-shaped spiral mazes cover older spirals. All are single line drawings
that originate from the lines above them. The figure is approximately 210 feet.

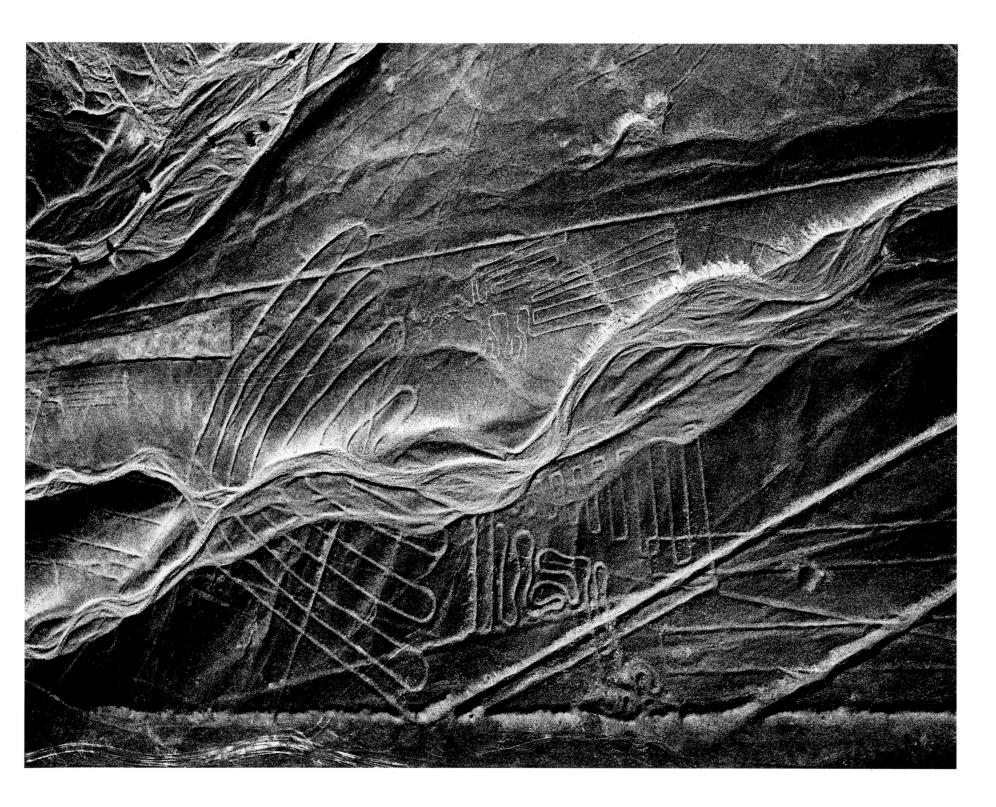

FEATHERS, 1979 The profile of a 130-foot marine bird shares the top
of a plateau with several geometric figures. The line traveling right to left
and intersecting the maze has been identified as a moonrise line. 19

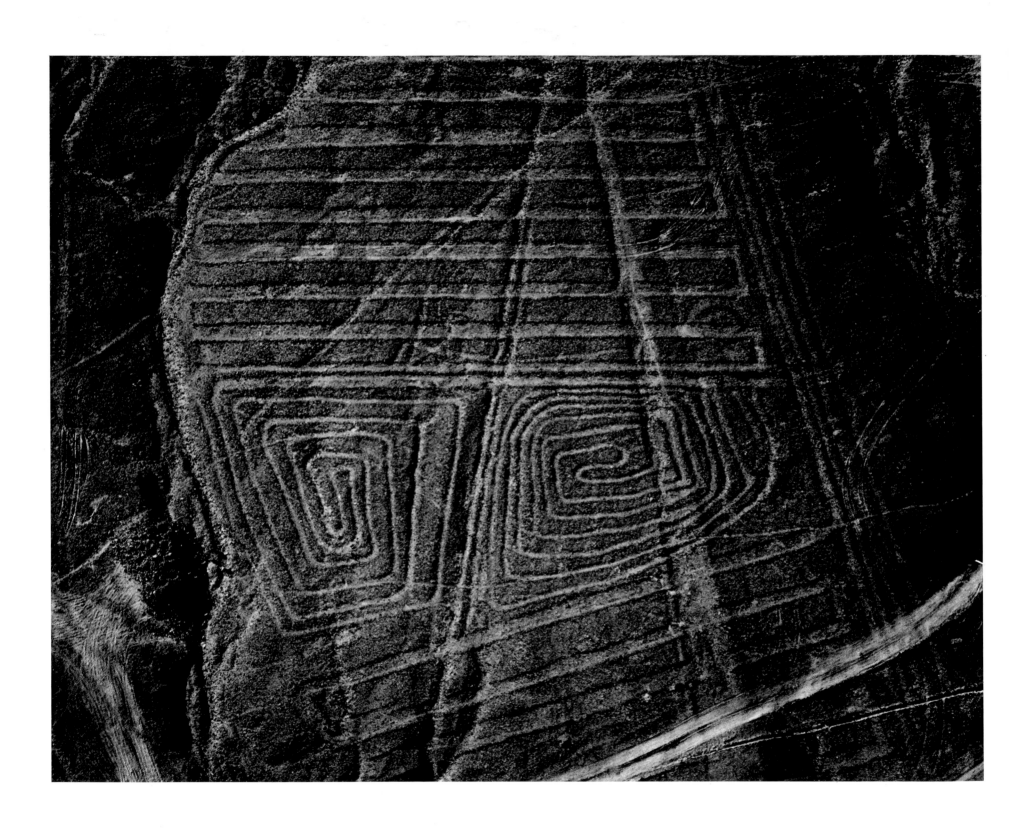

SQUARED SPIRALS, 1979 This 1,000-foot spiral/grid complex fits into a foothill plateau.
There are over 200 spirals on the pampa, many of which are part of elaborate grid or zigzag figures.

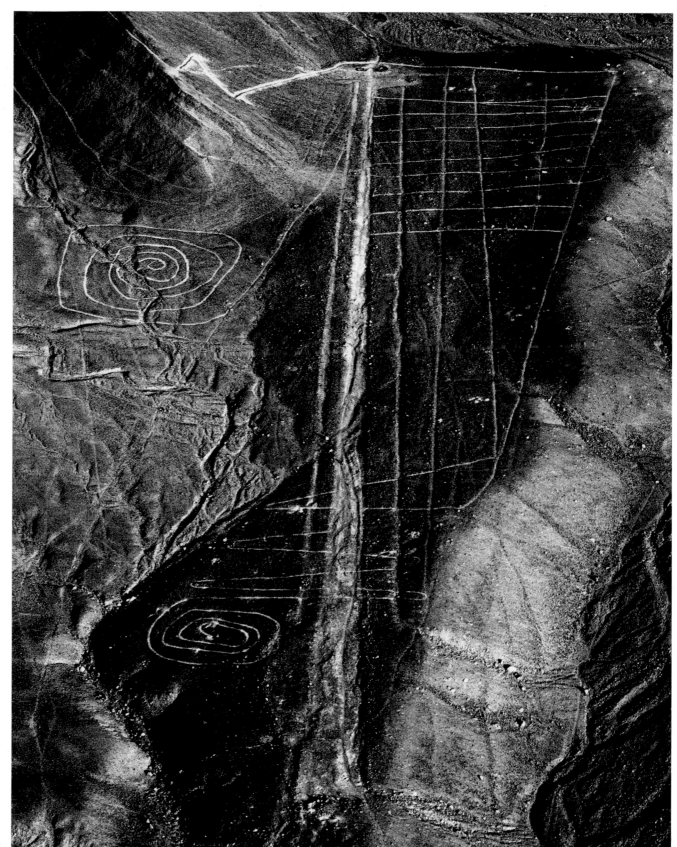

YARN & NEEDLE #2, 1979
This figure is quite similar to the figure
on page 16 but it is more crudely drawn.
Here, two spirals are attached to a zigzag,
a parallel grid and a tapering trapezoid.
The figure is approximately 3,000 feet long.

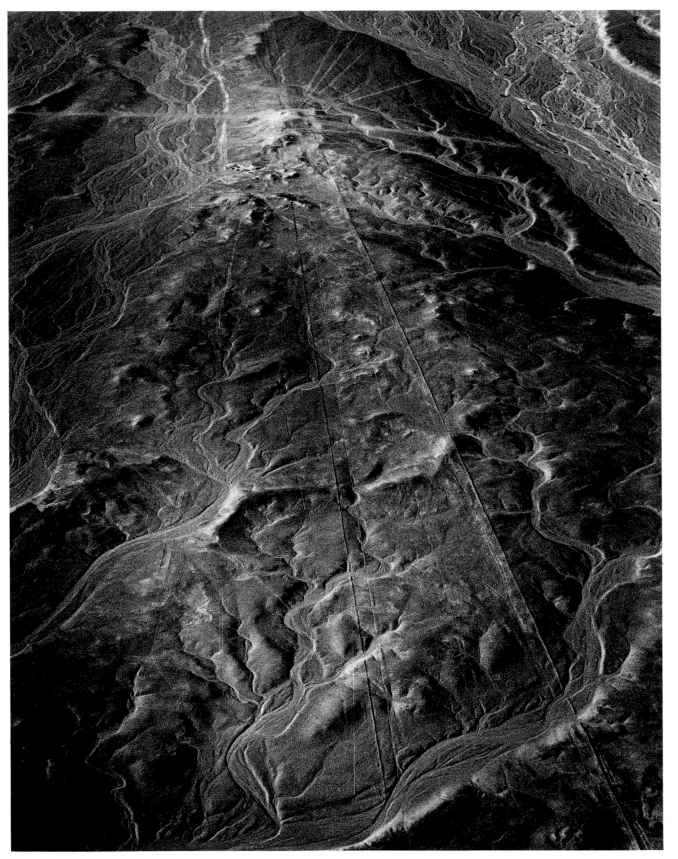

RADIATING LINES, 1979
Lines radiate from the hillock rather than
converge upon it. There are a number of such
ray centers on the pampa.

22

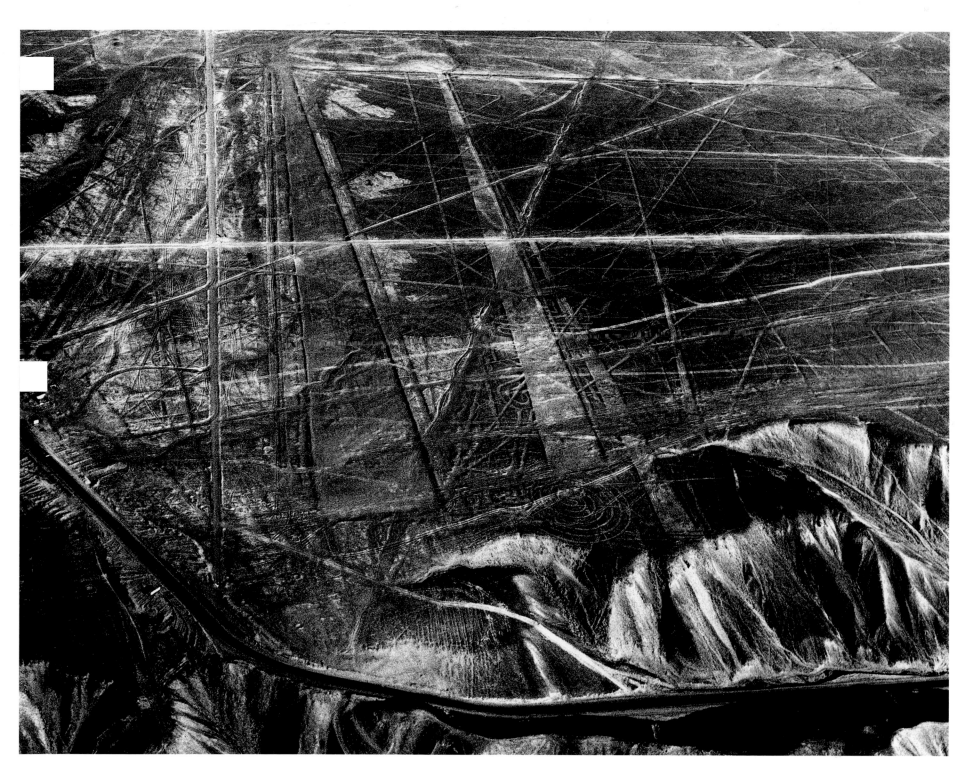

HIGH OVERVIEW, 1979 The Pan-American Highway appears in an upward-turning arc
embraced by Andean foothills. The spiral (lower right of center) has a diameter of about 260 feet.
A thin triangle touches the outer edge of the spiral and partially covers a 600-foot bird figure,
whose head and beak are visible. Straight lines are ancient. Modern vehicular damage is extensive.

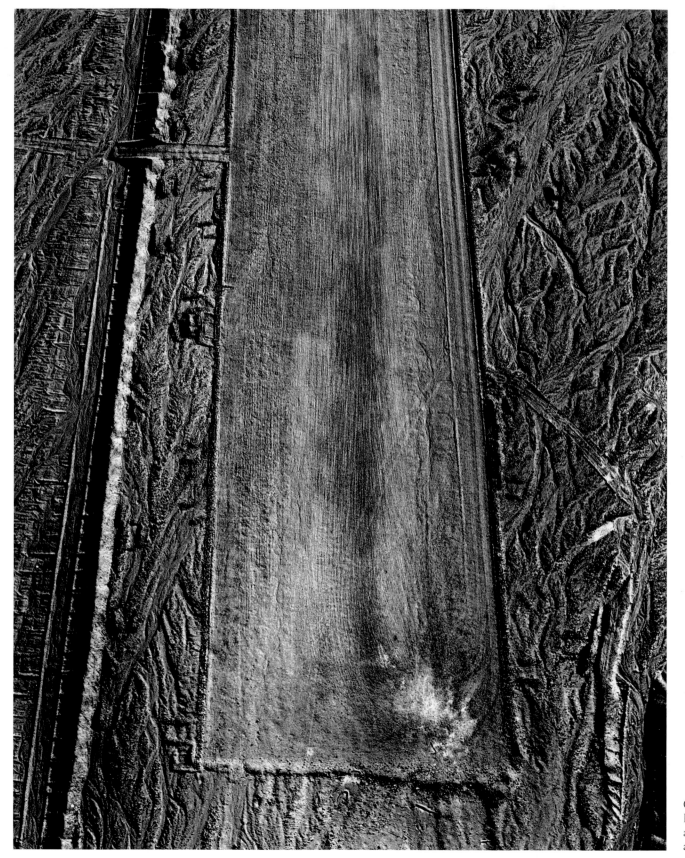

24

GREAT RECTANGLE, 1979
Rectangular clearings of various sizes
are common on the pampa. They probably served
as ceremonial gathering places.

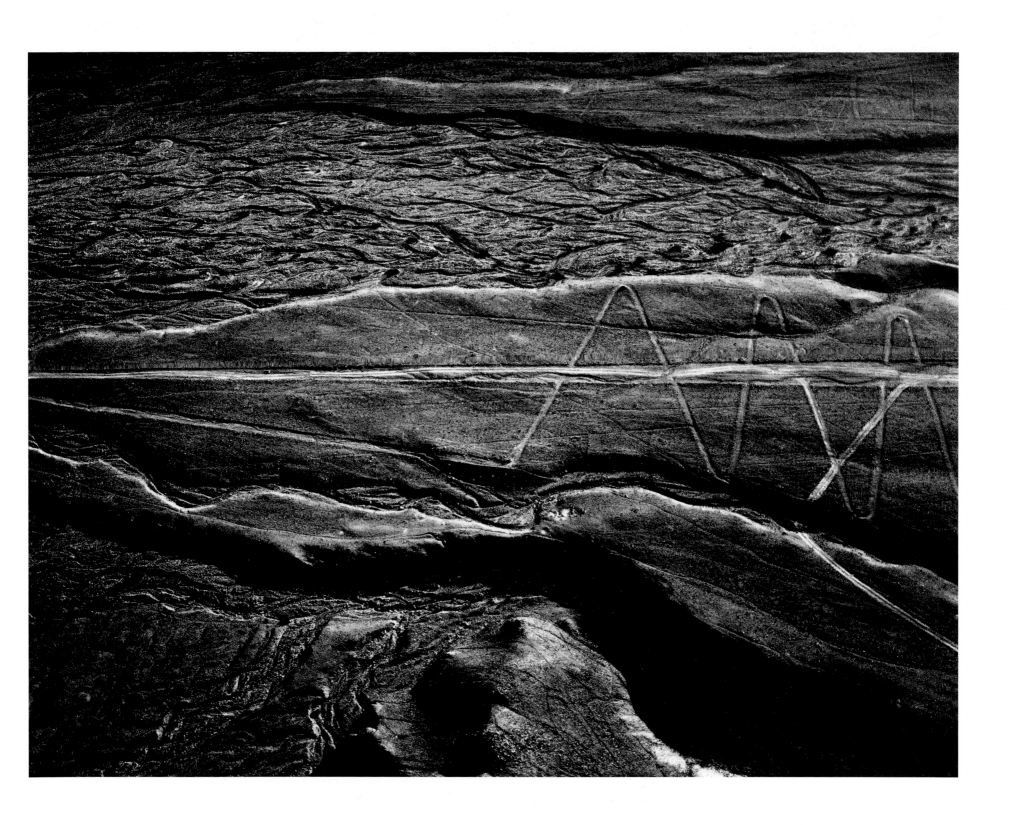

ZIGZAG, 1979 Zigzag geometric patterns are generally considered to be from
the Middle Nazca period and are often extensions of spirals and parallel grids.

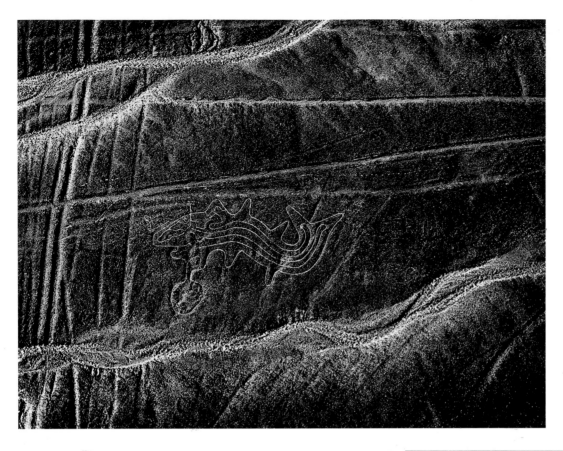

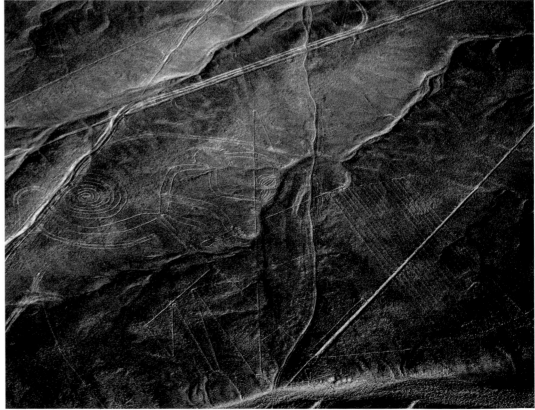

KILLER WHALE, 1979 This eighty-five-foot figure, a killer whale, was a popular motif on Nazca pottery and textiles associated with a head-hunting cult and fertility rituals. In the photograph, the trophy head hangs from the bottom of the whale.

MONKEY, 1979 This figure some 300 feet long is a spider monkey, although its tail turns up instead of down. The extension from the anal region might indicate that the figure was associated with fertility. One part of the extension can be traced to a parallel grid, while the other forms an elaborate zigzag.

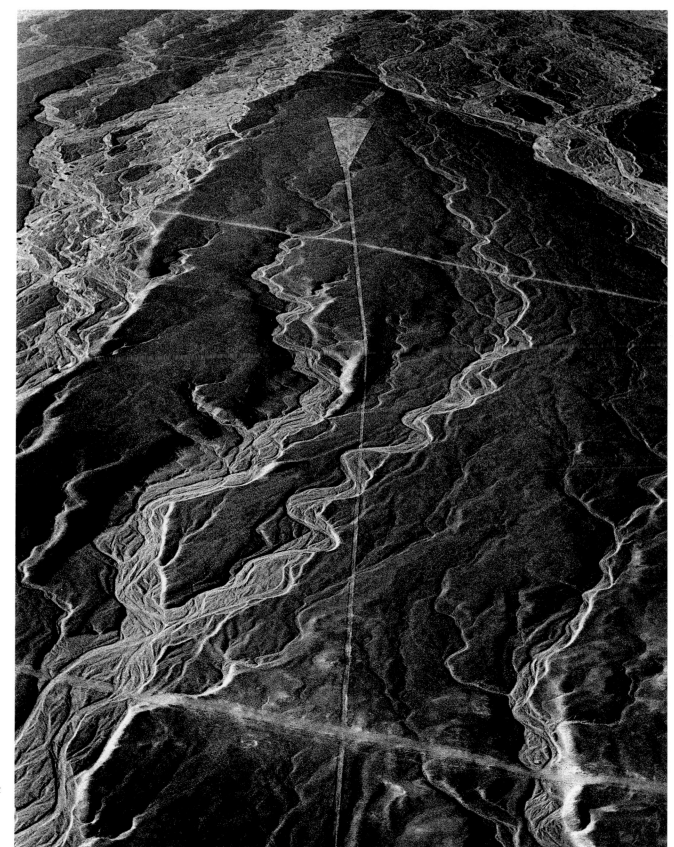

CONCORDE, 1979
Named "Concorde" by the photographer's pilot
(who was later killed in a plane crash over
Nazca), this 2,000-foot-long triangle has
a tail or "whip" stretching from its apex
and a smaller triangle bisecting its base.

OLD & NEW LINES, 1979 Ancient lines emanate from a hillock in the
darker portion of the photograph, and lines are also visible at the upper left.
At upper right is a small river and irrigation ditches of more recent origin.

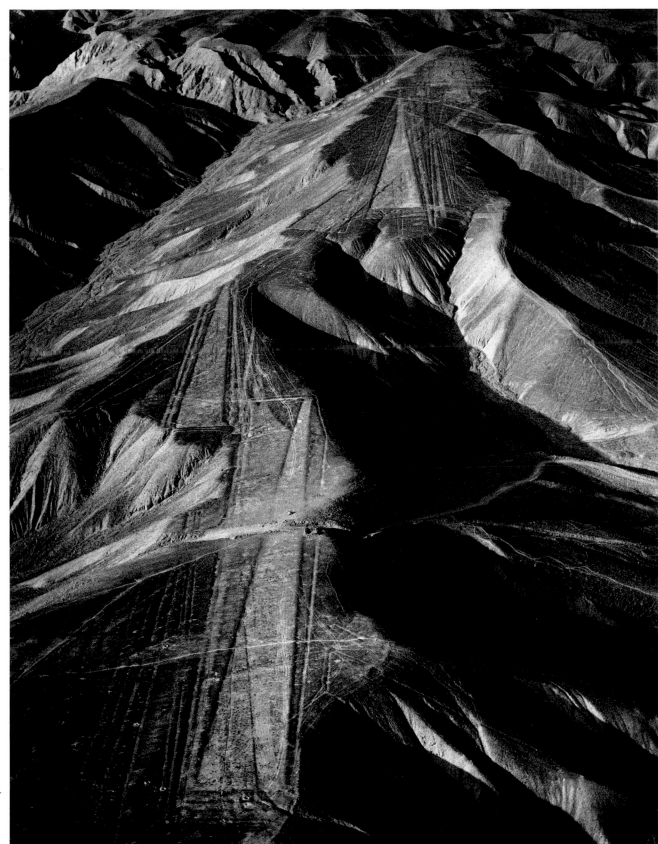

ARROWS OVER RISE, 1979
Trapezoids thousands of feet long are
etched on plateaus of the Andean foothills.
On both sides of the trapezoids are line
grids, and to the right of the figure
in the foreground is a small rise from
which numerous lines radiate.

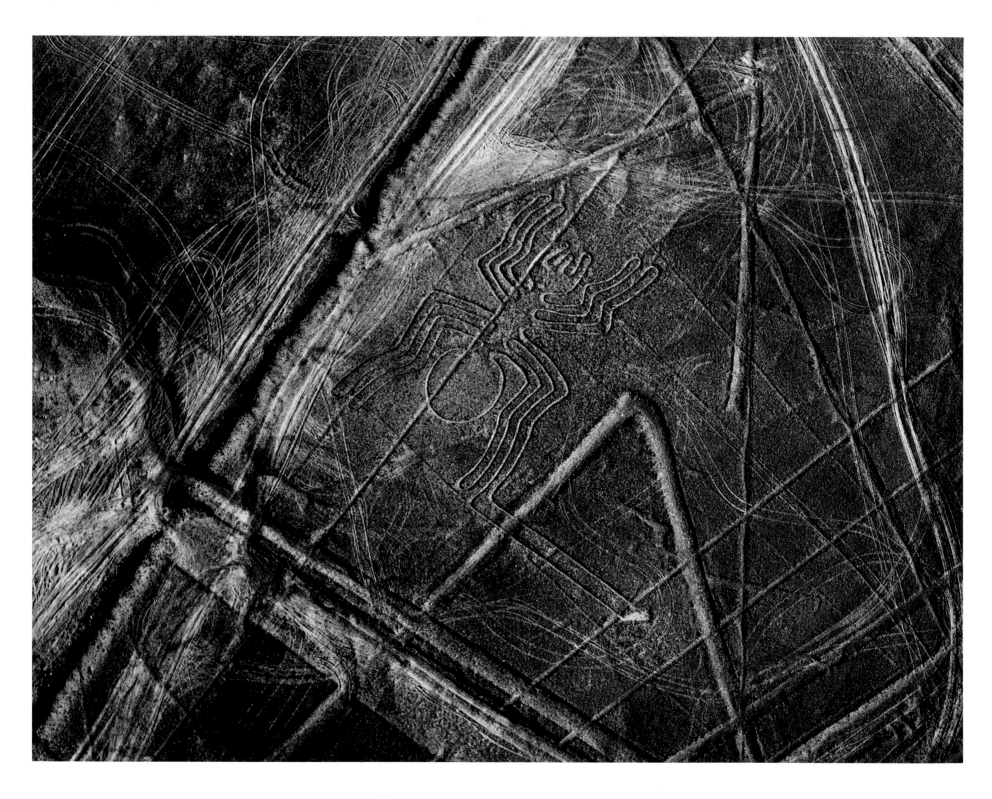

SPIDER, 1979 This 150-foot-long spider lies in an area that has suffered
much modern vehicular traffic. The spider was a popular motif on Nazca pottery and is believed
to be associated with fertility. The extension might have served as an entry point.

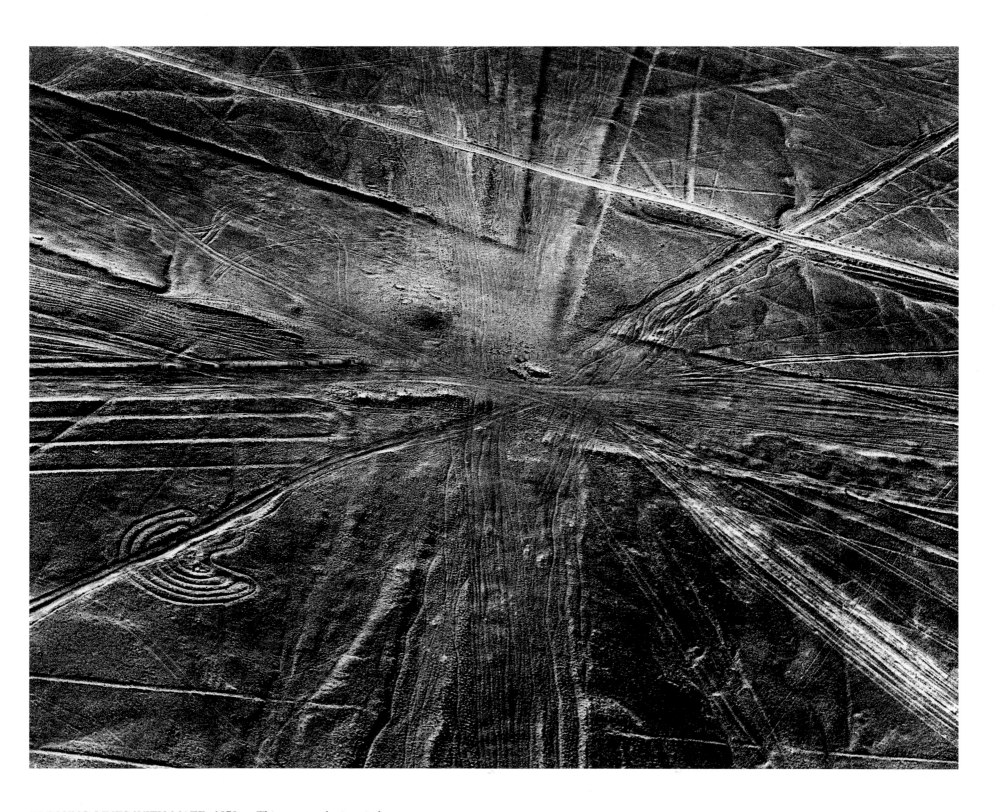

CROSSING LINES WITH MAZE, 1979 This maze or brain spiral measures some
65 feet across. In the center of the photograph is a mound that may have served
as a sighting point during the construction of this or other figures.

MAYA SITES, YUCATÁN AND CHIAPAS

In 1839 the American traveler and writer John Lloyd Stephens set out to explore the ruined Maya city of Copán in Honduras. Accompanied by an English artist, Frederick Catherwood, he eventually visited more than forty archaeological sites, including such now famous cities as Palenque, Uxmal, Chichén Itzá, Labná, Sayil, and Kabáh. Indeed, Stephens' celebrated books—*Incidents of Travel in Central America, Chiapas, and Yucatán* (1841) and *Incidents of Travel in Yucatán* (1843)—first brought the splendors of Maya civilization to widespread public attention and awakened serious scholarly interest in what is generally regarded as the most advanced culture ever known in pre-Columbian America.

Prior to Stephens' explorations, the Maya had been more myth than reality, a vanished civilization whose achievements lay buried for centuries under mounds of rubble and dense vegetation. Except for a few obscure ethnographic studies of contemporary Maya peoples and descriptions of ruins written by missionaries, Spanish soldiers, and occasional travelers, nothing was known about the ancient buildings and monuments scattered throughout the region. At best their history was shrouded in fanciful speculation that sought to identify them as the work of colonists from Europe or Asia—particularly Assyrians, Phoenicians, Egyptians, Chaldeans, Scythians, Israelites, Greeks, Hindus, Chinese, or survivors from the apocryphal lost continent of Atlantis.

With the advent of systematic research in the 1880s, these theories collapsed under overwhelming proof that the ancient Maya were racially akin to the American Indians. Moreover, it was shown that the rise of Maya civilization was an indigenous phenomenon that occurred wholly apart from European or Asian influences. The significance of this revelation was dramatically underscored as ruins of once thriving cities, evidence of remarkable intellectual accomplishments, and masterpieces of art began to emerge from obscurity, prompting the renowned archaeologist Sylvanus G. Morley to characterize the Maya as "the Greeks of the New World." Each new excavation has reinforced the validity of Morley's analogy; the brilliance and complexity of Maya civilization have become increasingly apparent, and its compelling aura of mystery has proved endlessly fascinating to scholars and laymen.

The Maya inhabited an area of approximately 125,000 square miles, encompassing what is now Guatemala, Belize, western Honduras, El Salvador, and the Mexican states of Yucatán, Campeche, Quintana Roo, Tabasco, and eastern Chiapas. Although this region is divided into two distinct geographical zones—highlands and lowlands—it is marked by extremely diverse terrain, climate, and vegetation. Most of the highlands district, which extends from Chiapas across southern Guatemala into El Salvador, consists of rugged mountains dotted with volcanic cones and dissected by basins, rift valleys, gorges, and lakes fed by numerous rivers. Because of the area's elevation, the climate is temperate, and some sectors are heavily forested with deciduous and evergreen trees such as oak, pine, laurel, juniper, and cypress.

By contrast, the lowlands constitute a massive limestone shelf projecting northward into the Caribbean Sea to form the Yucatán Peninsula. Its southern half is punctuated with hills, ridges, and seasonal swamps and is drained by several major river systems, but toward the north the terrain becomes increasingly flat and devoid of lakes and rivers. Vast sections of the lowlands are engulfed in rain forest composed of mahogany, cedar, rubber trees, sapodilla, ceiba, breadnut, wild fig, palms, ferns, vines, and many other types of vegetation. Lying entirely in tropical latitudes, this region is subject to heat, humidity, and heavy downpours during the rainy season from May to November. Despite the generally hostile nature of the lowland environment, with its unfavorable climate, poor soils, swarms of insects, and dense vegetation, it was nevertheless in the heart of this area that Maya civilization reached its highest level.

Like their present-day descendants—the more than two million Indians who still inhabit the region—the ancient Maya were not a homogeneous people. Instead, they included various groups who spoke related but mutually unintelligible languages, though these peoples shared deeply rooted cultural traditions. Very little is known about the earliest stages of Maya civilization, but recent discoveries have shown that agriculture and permanent villages appeared in northern Belize by 2000 B.C. During the second half of the Preclassic period (2000 B.C.–A.D. 250) there was increasing activity throughout the area. Excavations at numerous archaeological sites have yielded evidence of steady advances in population, sociopolitical organization, commerce, art and architecture, intellectual pursuits, and ritualism, along with the rise of powerful ruling hierarchies that eventually exerted control over all aspects of Maya society.

By the dawn of the Classic period (250–900) Maya civilization entered its golden age, an era of extraordinary cultural florescence.

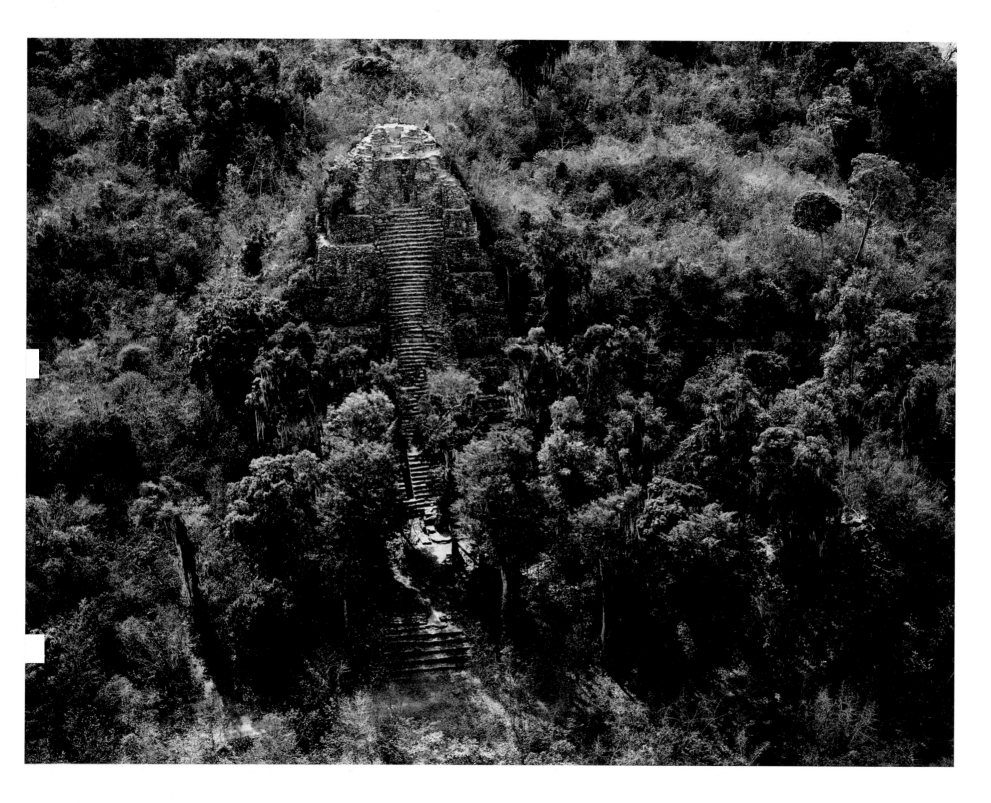

CASTILLO AT COBA, Quintana Roo, 1982 Sites at Cobá date from A.D. 623 to 1200, during
which time this center was one of the most important in the Maya world. The stepped pyramid
rises some 75 feet. Its nine terraces are crowned by a small temple.

Among the hallmarks of this period were the expansion of older cities and the proliferation of new sites. Even in the most inhospitable sections of the lowlands, the Maya erected populous centers filled with terraced pyramids, temples, palaces, shrines, residences, and courtyards. Surrounding the core of every city were clusters of thatched-roof peasants' dwellings. These support areas were situated near farmlands where crops were cultivated using agricultural techniques that ranged from simple slash-and-burn subsistence to more efficient methods utilizing raised fields and terraced hillsides.

Magnificent artistic achievements were also characteristic of Classic Maya civilization. Sculptors, potters, lapidaries, weavers, and painters produced works of exceptional technical skill and aesthetic impact. Among the treasures found in elite tombs and offertory caches are exquisite objects made of jade, bone, and shell—particularly jade ornaments and ritual objects, which were highly prized for their intrinsic beauty and their religious symbolism. Working without metal tools, Maya sculptors executed monuments, architectural embellishments, bas-reliefs, and figurines of astonishing refinement. By the third century A.D., the Maya began producing superb polychrome ceramics in a variety of shapes and surface treatments, and the cylindrical vases from Late Classic tombs—decorated with elegantly drawn narrative scenes—rival the finest pottery made anywhere in the ancient world. Unfortunately, the moist climate has destroyed most perishable arts such as textiles, wood carving, and basketry, but the few surviving examples of such works, together with representations in paintings and sculpture, confirm that the Maya were also masters of these media.

In the fields of astronomy, calendrics, hieroglyphic writing, and mathematics, the Maya had no equals in pre-Columbian America. They possessed a highly accurate calendar based on careful measurements of the solar year. Astronomers charted the movements of the sun, moon, and Venus (there is evidence that they may have studied Mars, Jupiter, Mercury, and Saturn as well), and one of the three surviving Maya books or codices of unquestioned authenticity—the Dresden Codex—contains tables for predicting lunar eclipses. Calendrical, historical, and esoteric information was recorded on stone monuments and in ceramics, wall paintings, and codices, using hieroglyphic inscriptions that constitute the only true written language ever invented in the New World. Recent research has demonstrated that many of these texts relate to the genealogy, history, and military exploits of ruling dynasties, but despite intensive efforts by scholars to unravel the complexities of Maya inscriptions, they have not yet been fully deciphered. Among the readable glyphs are the numerical symbols, and we know that the Maya used a mathematical system that incorporated the principle of zero and enabled them to calculate large numbers with a facility unknown in Europe until the Middle Ages.

Nor can there be any doubt that many Classic-period settlements were urbanized (with buildings designed to serve religious and secular functions), that some of the larger centers exercised political control over neighboring cities, or that Maya society was highly complex. At the pinnacle of the social order stood a wealthy and powerful ruling elite whose status was hereditary. Apart from their supreme authority in matters of state, the members of this class also controlled natural resources, commerce, public works, and military activities. Occupying a middle position on the social scale were civil administrators, merchants, craft specialists, and artists, all of whom probably worked under the patronage of the ruling elite. Finally there were the peasants, who, despite their lowly position, formed the backbone of Maya civilization since they provided the agricultural production and the labor necessary to support the upper classes, erect cities, and carry on warfare.

Every aspect of life was influenced by religious concepts, and the Maya world view encompassed a perception of reality in which time, space, the physical world, and supernatural phenomena were interrelated parts of a universe where humans and deities interacted on all levels. The Maya worshiped a bewildering array of gods. Apart from a supreme deity known as Itzamná, there were gods associated with the sun, the calendar, childbirth, death, warfare, commerce, agriculture, and many other facets of the natural and supernatural realms. As portrayed in Maya iconography, these deities present a bizarre appearance—a curious mixture of human physical traits with those of animals and mythological creatures. Some gods could alter their appearance and specific functions, and were capable of either benevolent or destructive acts toward humankind. In an effort to placate their gods, the Maya observed an endless round of rituals, including prayers, dancing, chants, offerings, human sacrifice, and bloodletting rites that consisted of piercing the body with thorns, stingray spines, or obsidian blades. Other rituals were associated with accession to

Editor's Note: Because of an oversight, the following corrections made by the author were omitted on page 32 and preceding pages.

The word "Maya" is generally used as both a noun and adjective; the term "Mayan" refers to the languages spoken by the Maya people.

Line 4: "then" should read "than".

Line 5: accents should appear on Chichén Itzá, Labná and Kabáh.

power and ancestor worship among the royalty, whose authority was believed to be sanctioned by divine patrons.

Religious ideology was also embodied in art, architecture, mythology, and literature. For example, the surviving Maya codices contain information pertaining to ritualism, divination, and prophecy, and there is evidence that many books of this type once existed. (In 1562 a Franciscan friar, Diego de Landa, burned a large number of codices in the town of Maní in Yucatán, declaring that they "contained nothing in which there was not to be seen superstitions and lies of the devil.") Several post-Conquest manuscripts—compiled by Maya who had learned to read and write Spanish—have shed considerable light on ancient religious practices; and one such book from the Guatemalan highlands, the *Popol Vuh*, not only provides valuable insight into religious beliefs but is a remarkably eloquent work that echoes the brilliance of a long-vanished literary heritage. These ethnohistoric sources, together with accounts by early Spanish chroniclers and the oral traditions of contemporary Maya peoples, have confirmed the richness of native mythology and folklore.

At the height of its glory, Maya civilization began to decline early in the ninth century A.D. In rapid succession, virtually all of the once splendid cities in the southern lowlands were abandoned. By 909 the last known dated monument had been erected in this area; temples and palaces fell into disuse amid the ever encroaching rain forest; and shifts in population eventually left most of the region deserted. The collapse of Classic Maya culture remains one of the most enigmatic events in the history of archaeology, and numerous theories have been suggested to explain a catastrophe of this magnitude: invasion, natural disasters, epidemics, peasant uprisings, agricultural failure. Scientific evidence has so far failed to verify any of these possibilities as the sole cause of the collapse, although archaeologists have begun to identify a variety of social, economic, and political factors that may have contributed to the decline.

After 900 the emphasis of Maya civilization shifted from the southern lowlands to the northern Yucatán Peninsula. Here a number of major cities such as Uxmal, Labná, Kabáh, and Sayil continued to flourish until around 1000, and new centers were established, some of which were still inhabited when the Spaniards arrived in the 1500s. During this period—the Postclassic (900–1500)—strong Mexican influences derived primarily from the Toltecs appeared in Yucatán, especially at the great city of Chichén Itzá, which became the most powerful center in Yucatán from about 1000 to 1250. With this influx of Mexican traits came an emphasis on new religious cults, human sacrifice, militarism, and commerce, which drastically altered the older elite-oriented values. Eventually the Yucatán Peninsula split into numerous independent provinces governed by petty chieftains who were preoccupied with warfare and mercantilism. By 1517 the tide of the Spanish Conquest began to engulf Maya civilization, plunging the vestiges of this remarkable legacy into oblivion until they were resurrected by archaeologists.

Despite intensive research, which has rapidly accelerated our knowledge of every aspect of Maya civilization, there are still many unanswered questions. Our incomplete understanding of the written language and the fact that Maya culture is unrelated to any Old World society have made it extremely difficult to comprehend the cultural context underlying the Maya's accomplishments. Unquestionably, however, one of the most readily accessible manifestations of Maya civilization is its architecture. Walking among the pyramids, temples, palaces, and courtyards of cities such as Uxmal, Chichén Itzá, Tikal, or Palenque, even the most casual visitor is struck by the often gigantic scale of these structures, their ornate embellishments, the expenditure of labor required to erect them, and the diversity of regional architectural styles.

The monumentality of these structures is dramatically revealed in Marilyn Bridges' spectacular photographs. Here the splendors of Maya civilization are spread out before us in all their grandeur—ultimate expressions of the social, religious, and aesthetic fabric of these extraordinary people preserved in earth, stone, and mortar. We sense the grand design of Maya cities in a way that is not possible from the ground. We see, too, the relationship of buildings to the landscape, especially the sea of jungle that often dwarfs even the most impressive temples. Indeed, Bridges' views of structures engulfed by vegetation at Yaxchilán and Cobá leave no doubt as to the enormous obstacles faced by Maya builders in erecting and maintaining their creations.

Apart from capturing the visual impact of Maya architecture, Marilyn Bridges has provided powerful confirmation of the dedication of laborers and artisans to the ideals that motivated such a massive investment of time and effort. Moreover, her photographs are a unique expression of her personal encounter with the mystique that has lured generations of explorers, travelers, scholars, writers, and artists to probe this most fascinating of all pre-Columbian cultures.

CHARLES GALLENKAMP

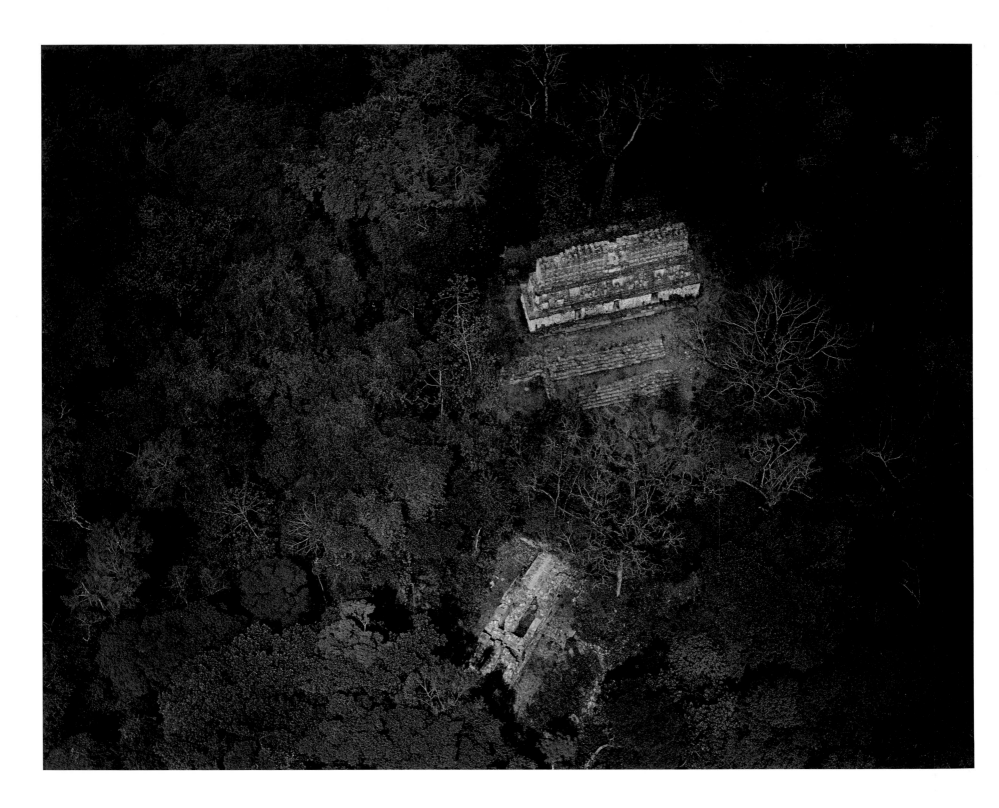

TEMPLE 33 AND TEMPLE 20, **Yaxchilán**, Chiapas, 1982 Located in dense jungle, this Classic Maya site was an important commercial and ceremonial center through the eighth century. In the photograph, Temple 33 (upper right) with a full roofcomb stands atop a steep hill reached by a stairway of stepped terraces. Temple 20 is a small set of ruins below Temple 33.

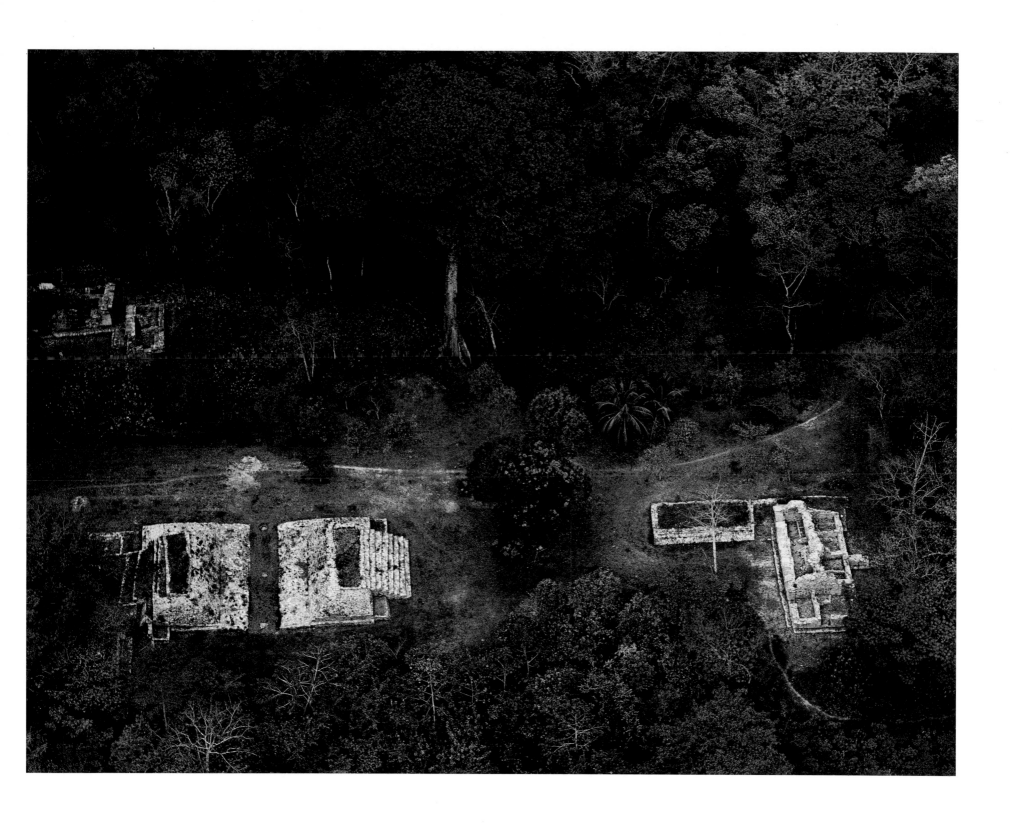

RUINS IN THE JUNGLE, Yaxchilán, Chiapas, 1982

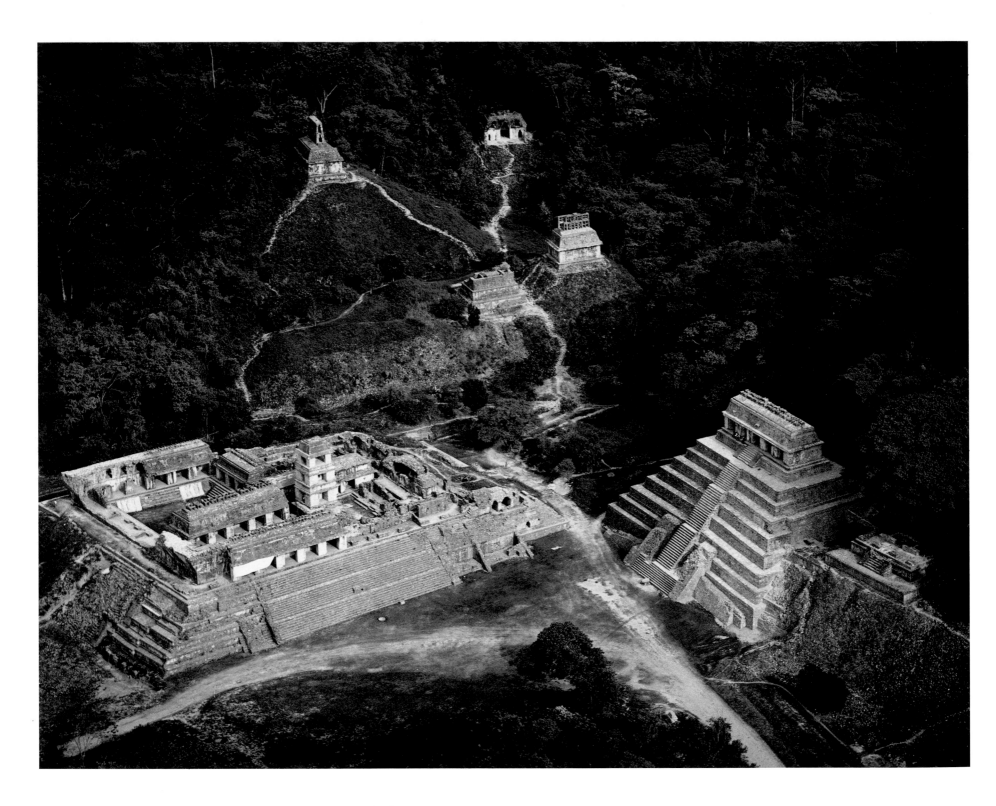

OVERVIEW, Palenque, Chiapas, 1982 The excavated portion of Palenque covers some
240,000 square yards, which is only a small portion of this great Maya city that flowered during
the Classic period. The most outstanding buildings were constructed from A.D. 615 to 701.

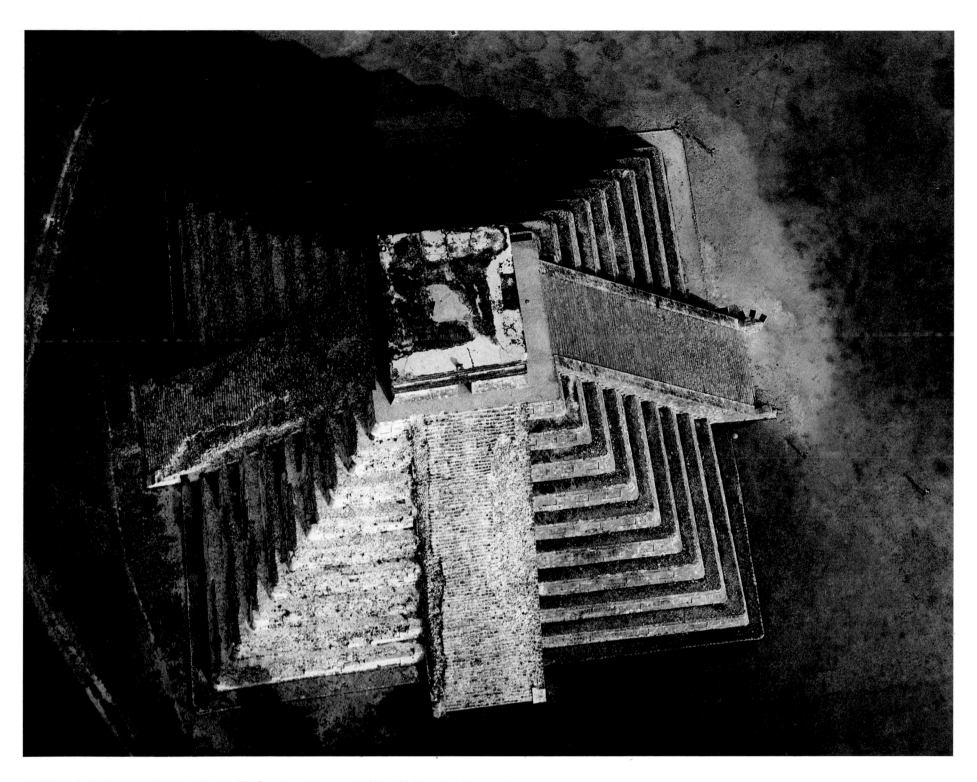

CASTILLO FROM PERPENDICULAR, Chichén Itzá, Yucatán, 1982 Chichén Itzá became the most important
Maya city in Yucatán between A.D. 1000 and 1250. The 80-foot-high castillo was built in the ninth century and is believed
to be dedicated to Kukulcan, the mythical Toltec leader. Four staircases have 91 steps each for a total
of 364 days (one day would be allowed for the temple on top to complete the calendar year).

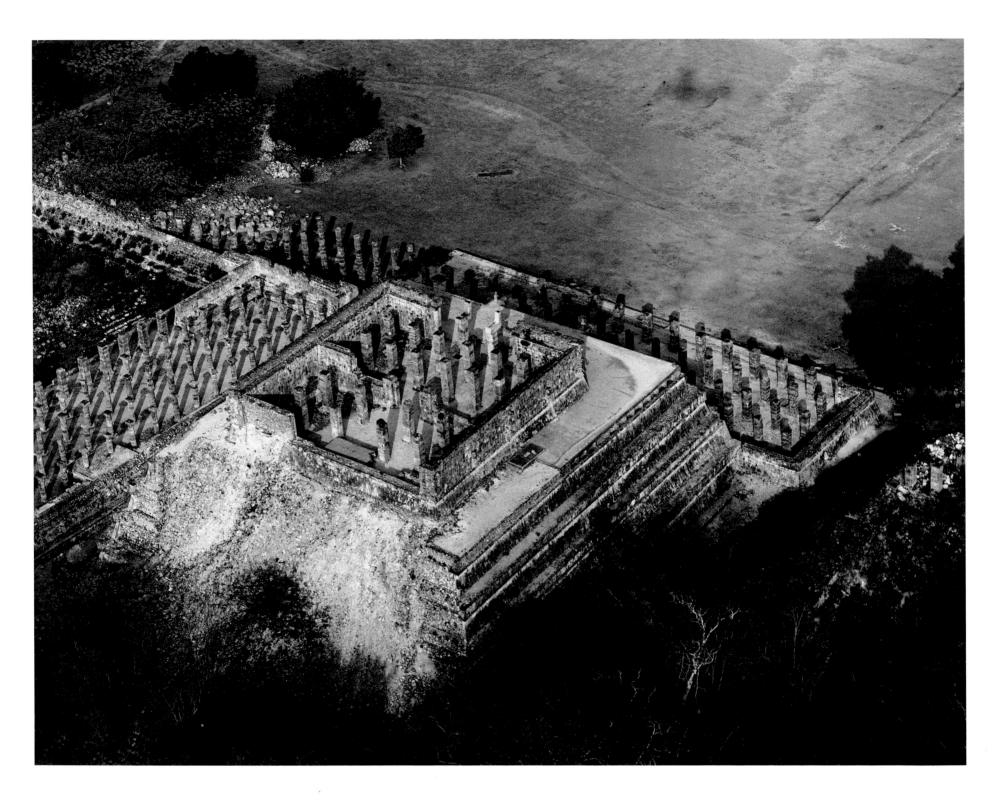

TEMPLE OF THE WARRIORS, Chichén Itzá, Yucatán, 1982 This Post-Classic structure is
Toltec in design. It rises in four platforms and is flanked on the south and west sides by nearly
200 round and square columns, many of which are carved in relief and focus on warrior themes.

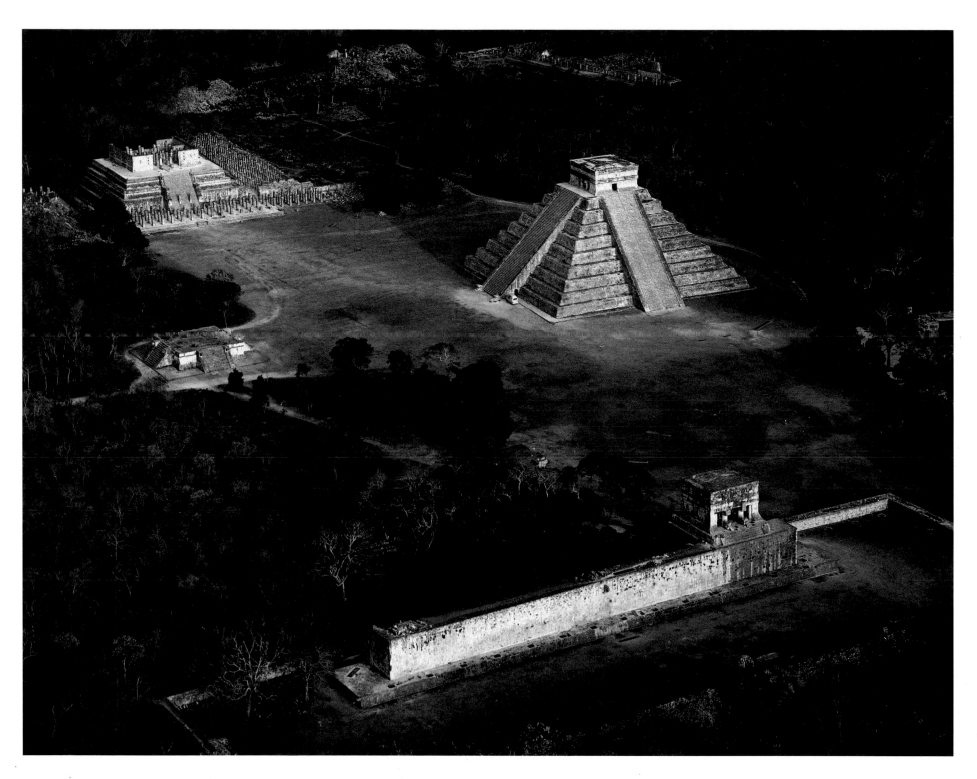

OVERVIEW OF NORTH SECTION, **Chichén Itzá, Yucatán, 1982** The view across the Main Plaza covers
195,000 square yards. Center-right is the castillo and bottom is the Great Ball Court, built around A.D. 1200
and one of the largest in Mesoamerica. Center-left is the Venus Platform, which may have been used for ritual
dance and drama. Upper-left is the Temple of the Warriors and several other structures.

EL MERCADO, Chichén Itzá, Yucatán, 1982 The Mercado is of Toltec origin and was probably
constructed between A.D. 1000 and 1200. The colonnade that runs top to bottom is built on a 250-foot raised platform.

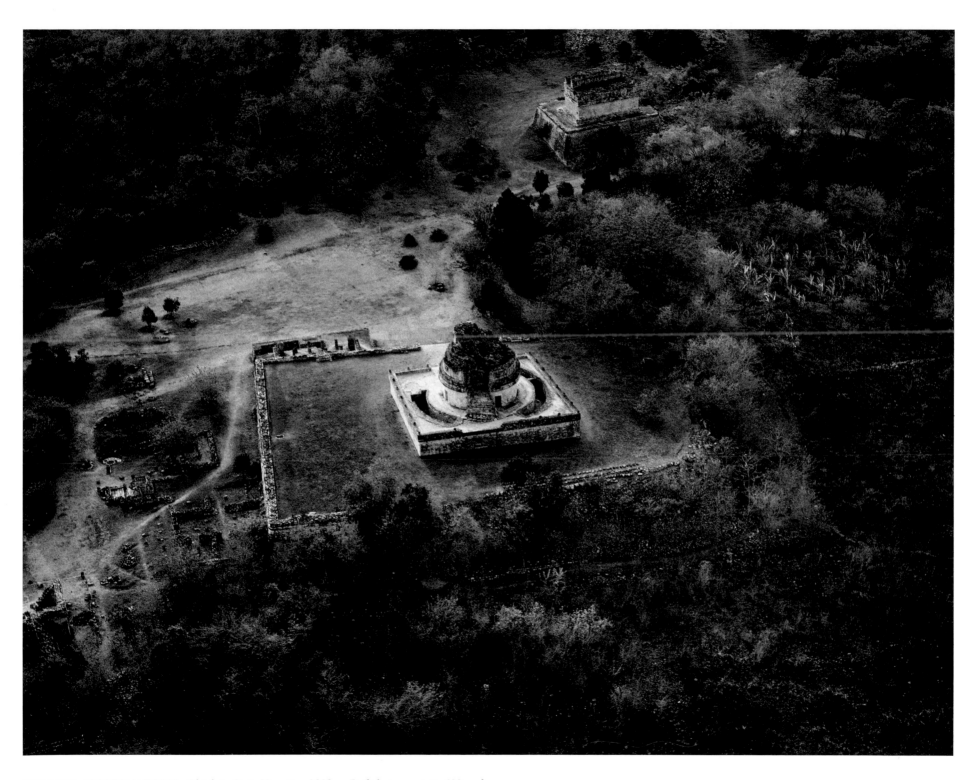

CARACOL (OBSERVATORY), Chichén Itzá, Yucatán, 1982 Built between A.D. 600 and
1200, the observatory constitutes the oldest Toltec-Maya building at Chichén Itzá. The plan of the
observatory windows and shafts leading to these windows is oriented to indicate the azimuths
for south and west, the equinoxes, and the extreme setting positions of the planet Venus.

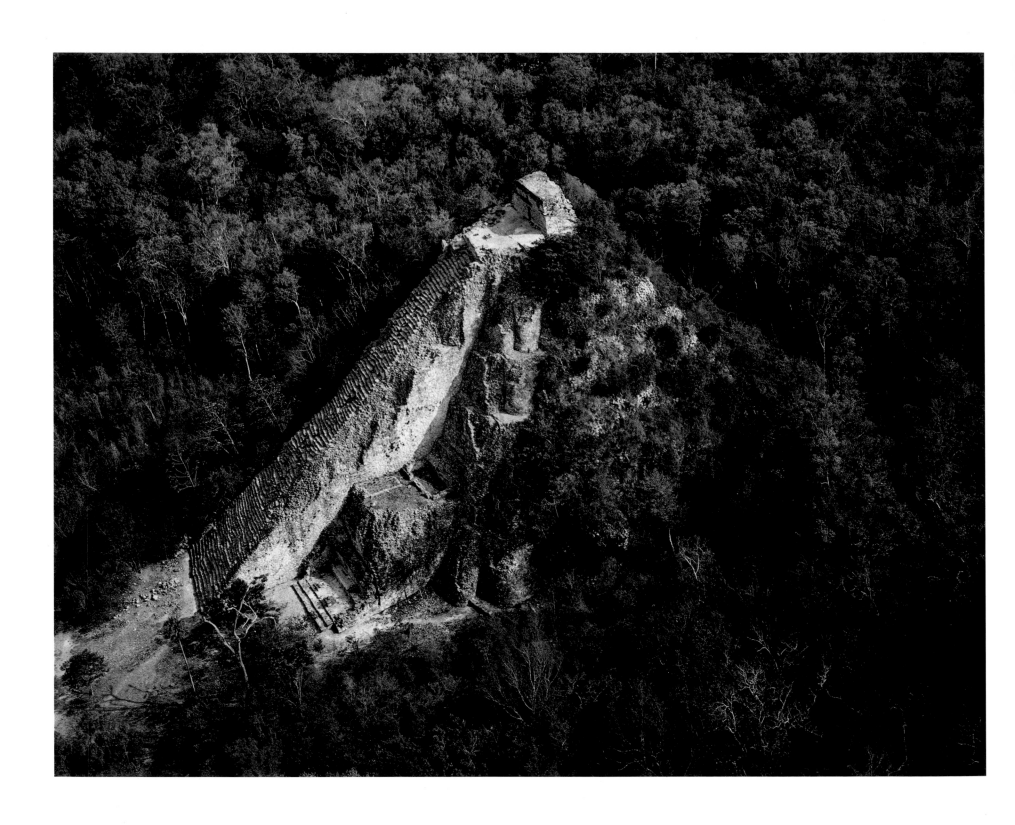

NOHOCH MUL, Cobá, Quintana Roo, 1982 The stepped pyramid in the Nohoch Mul section of Cobá
rises to a height of 78 feet. It is from the Late Classic Period and resembles pyramids at Tikal in Guatemala.

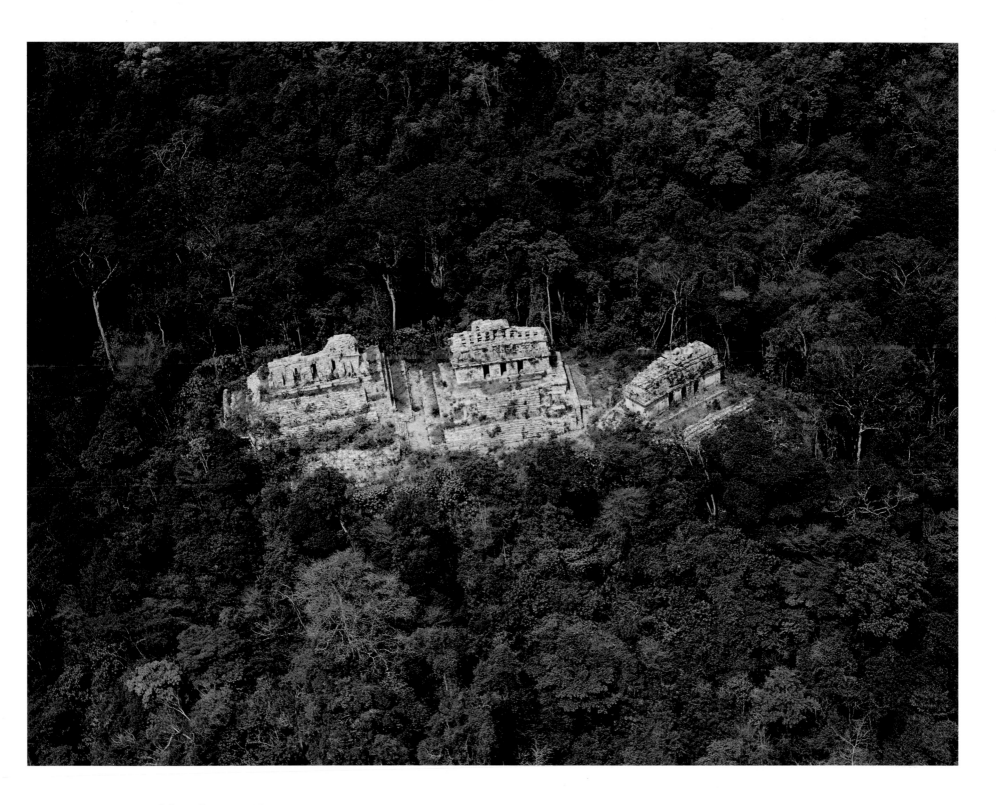

THREE TEMPLES, **Yaxchilán, Chiapas, 1982** These three buildings are known as
the South Acropolis. A stairway led from Temple 41 (left) to a plaza some 300 feet below.
The stairway was once an esplanade of stairs, platforms, and stelae-lined terraces.

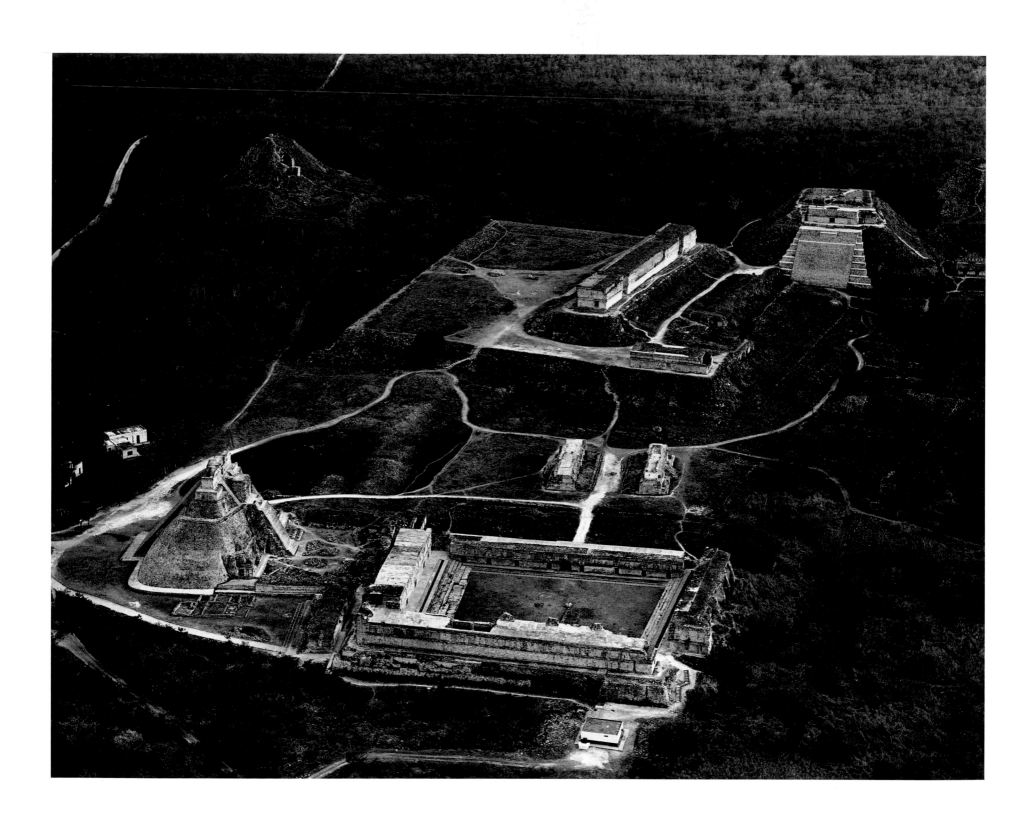

OVERVIEW, Uxmal, Yucatán, 1982 Most of the buildings at Uxmal were constructed between
A.D. 600 and 900. The overview covers most of the excavated portion of the city, an area of approximately 312,000 square yards.

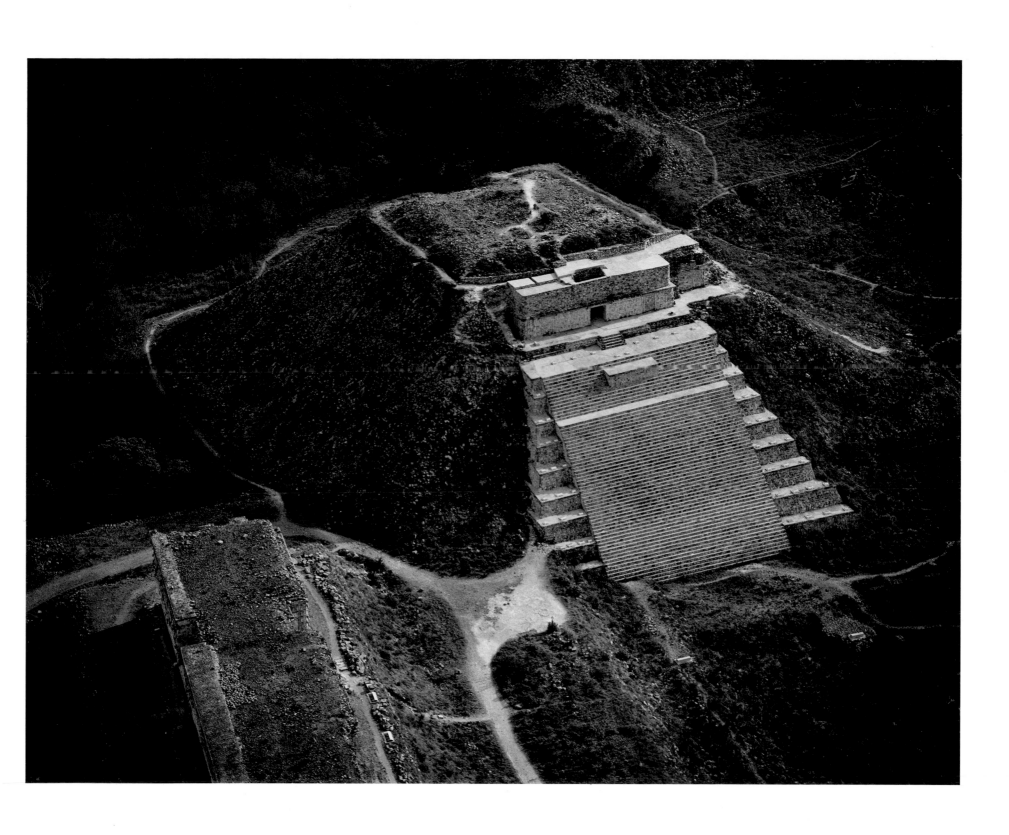

GREAT PYRAMID, Uxmal, Yucatán, 1982 A partially restored truncated pyramid. Around four
sides of its uppermost level were palace-type buildings. Bottom-left is part of the unrestored Southwest Pyramid.

47

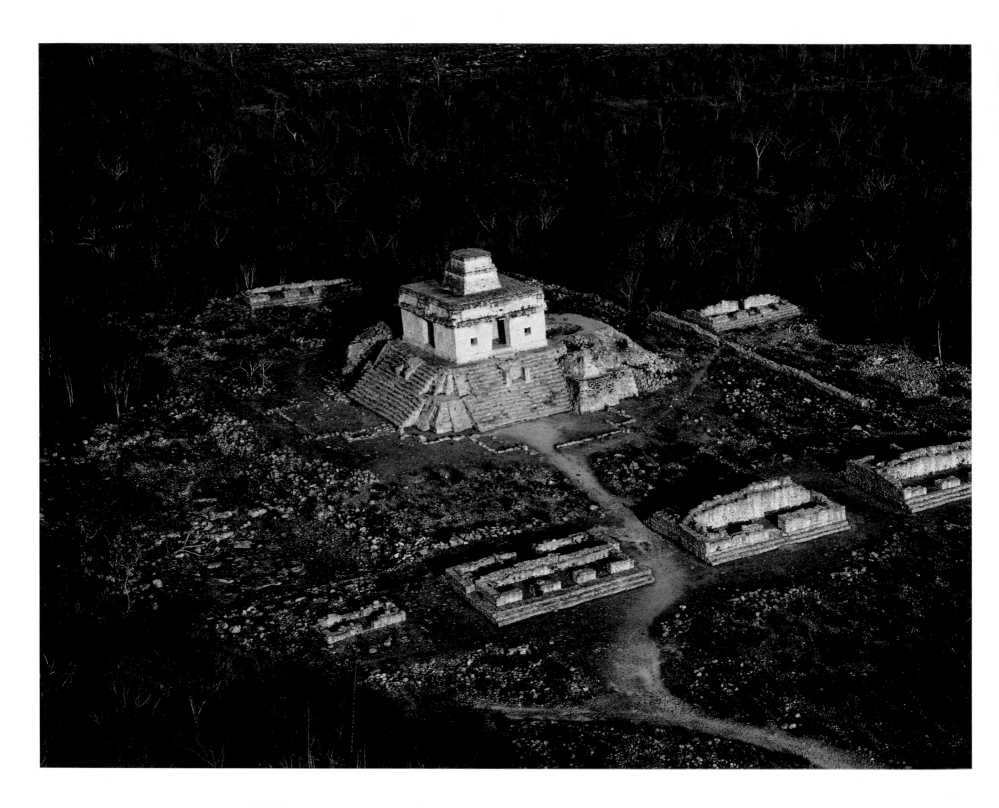

TEMPLE OF THE SEVEN DOLLS, Dzibilchaltún, Yucatán, 1982 Dzibilchaltún is one of the oldest
continuous settlements in the New World, having been occupied since 1500 B.C. The reconstructed
late fifth-century temple is notable for its windows, which are rare in Mesoamerica.

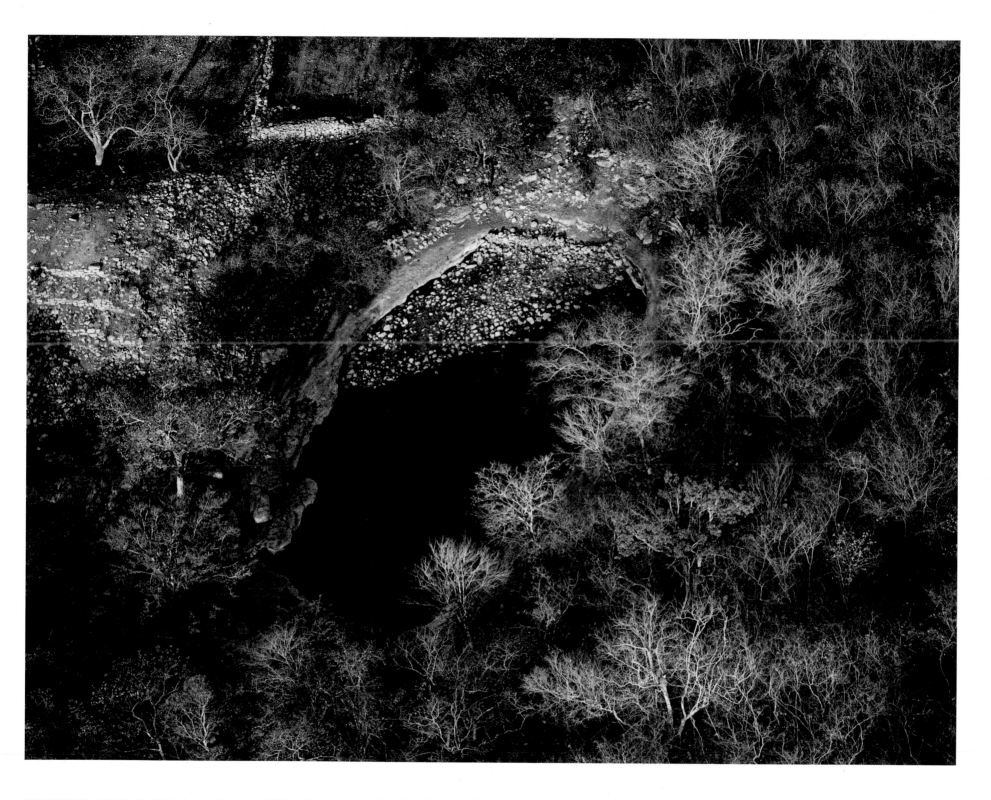

CENOTE XLACAH, Dzibilchaltún, Yucatán, 1982 The ceremonial well in the Central
Causeway of Dzibilchatún reaches a depth of about 135 feet. Divers have brought up more than
30,000 offerings tossed in by the Maya. Today, the cenote is a popular swimming hole.

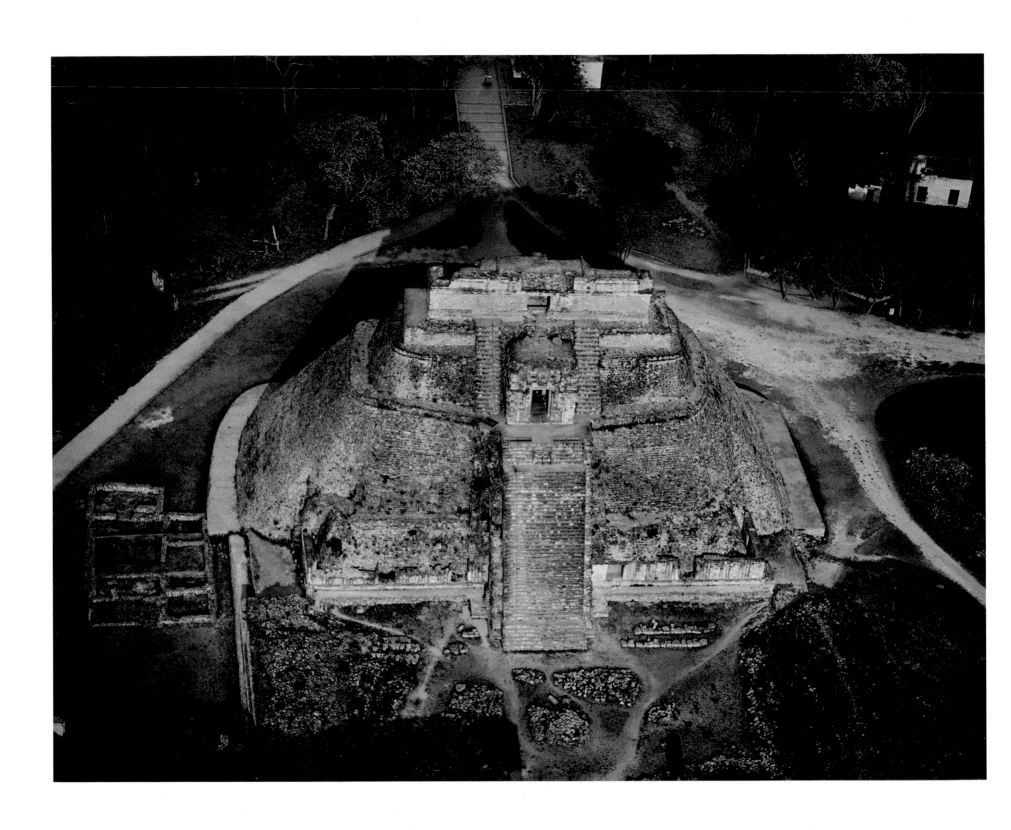

PYRAMID OF THE MAGICIAN, Uxmal, Yucatán, 1982 Built between A.D. 569 and 950, the pyramid is
approximately 93 feet in height and is the tallest building at Uxmal. Temple 5 at its summit is the House of the Magician.

UNCOVERED RUINS, Mitla, Oaxaca, 1982 This Zapotec and Mixtec site in southern Mexico
derives its name from "Mictlan," which means "place of the dead," and at its earliest stage it might have
been a ceremonial center and burial site. Mitla was destroyed in 1494 by the armies of Ahuitzotl, an Aztec king.

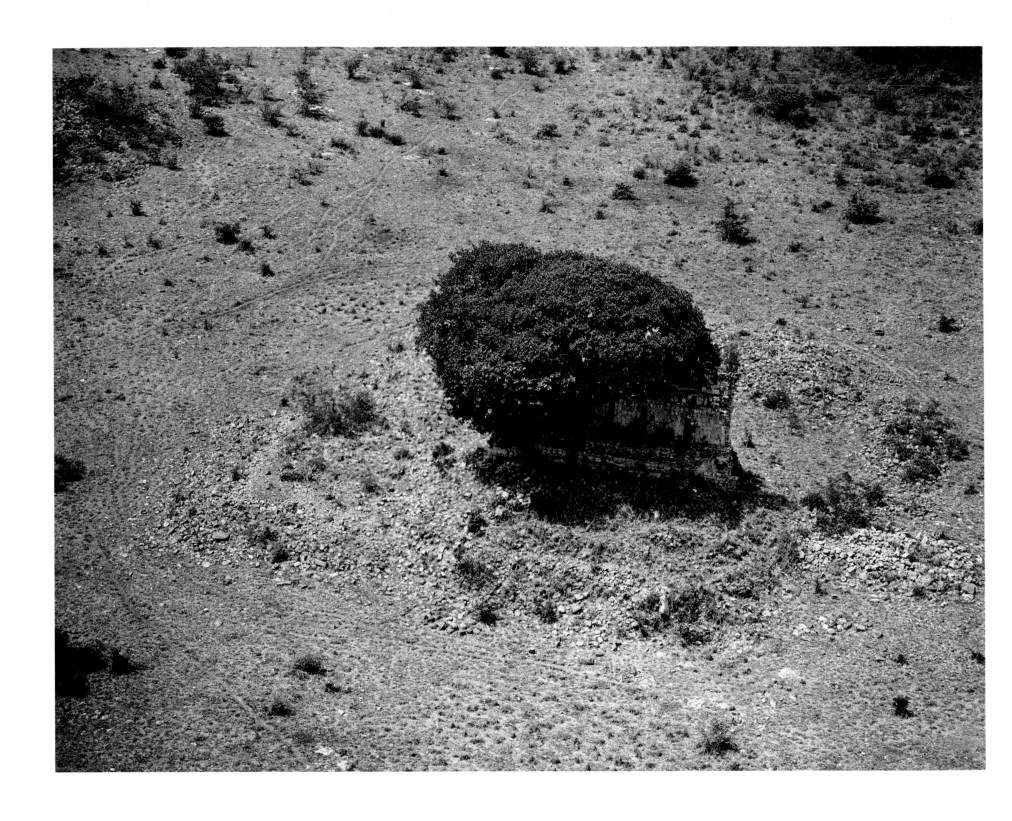

RUINS IN XCUPIL, Campeche, 1982 Unexcavated remains of a
small temple in Xcupil, near Hopelchen. The ruins are sometimes identified as Toheok.

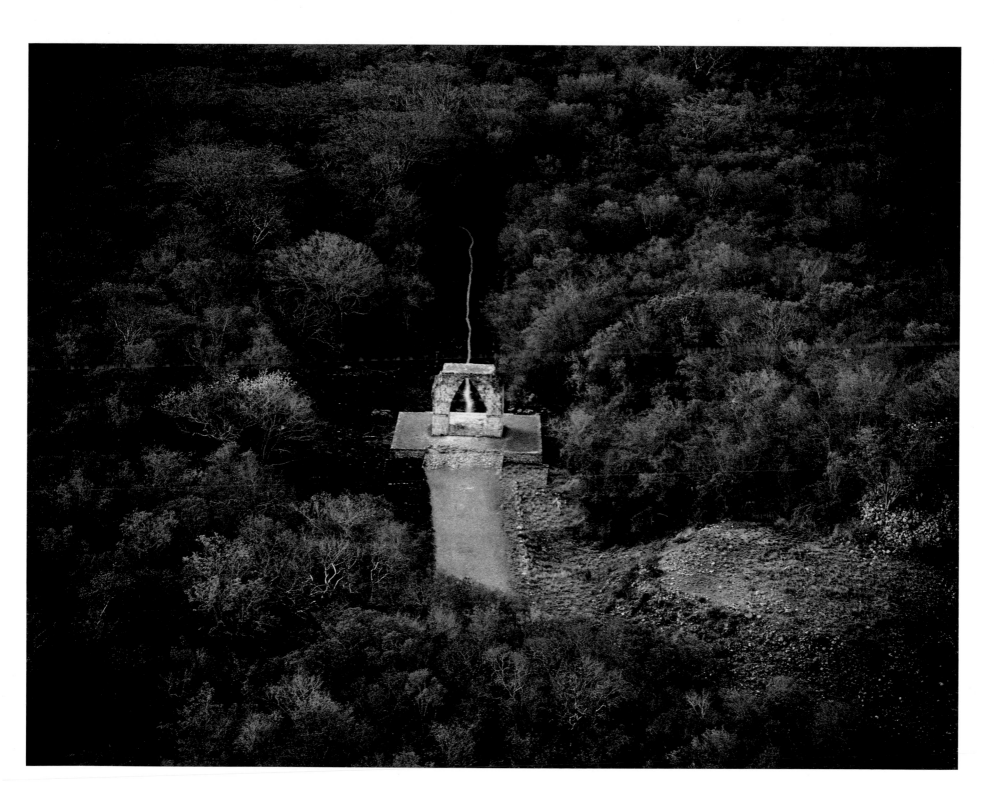

ARCHWAY. Kabáh, Yucatán, 1982 In the Late Classic period the Maya constructed a paved, elevated
causeway some 15 feet wide from Uxmal to Kabáh, a small satellite center in the Puuc Hills about ten miles away.
That part of the causeway which led into Kabáh was highlighted by an arch that has been restored. 53

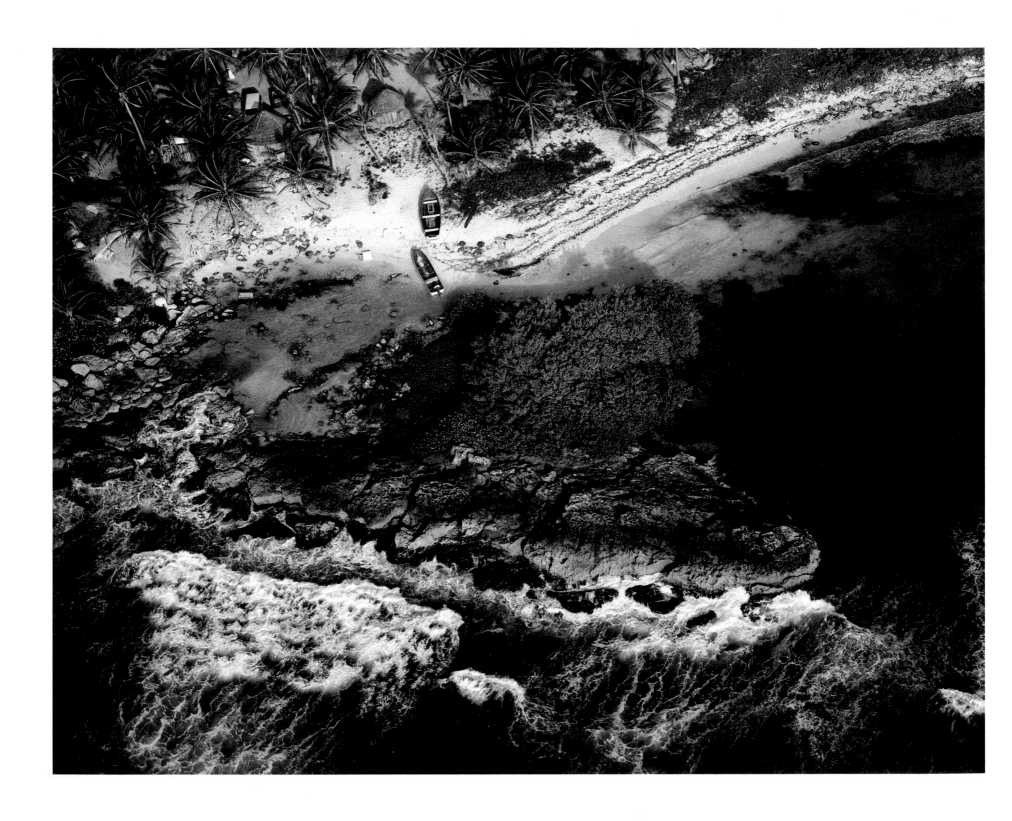

CARIBBEAN SEA, Tulúm, Quintana Roo, 1982 Thatched huts under palms
and two fishing boats south of the ancient Maya city of Tulúm.

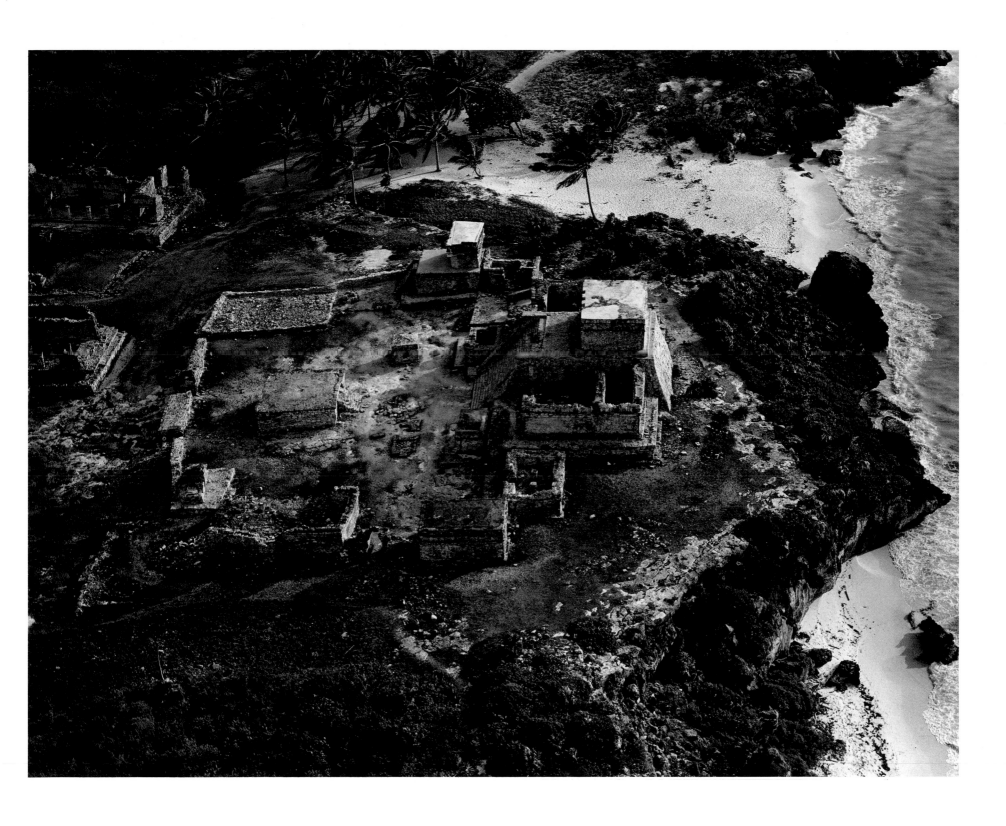

TULUM FROM SOUTH, Quintana Roo, 1982 Tulúm was a planned city containing some 50 structures and was
first occupied about A.D. 1200. The view is of the inner courtyard. Right is the castillo, with the Temple of the Diving God at its summit.

AMERICAN LANDSCAPES

Time becomes space in Marilyn Bridges' aerial photographs of Native American sacred sites and contemporary rural landscapes, enhanced or marred by nature and society. The distance from which she photographs—great in terms of daily experience, small in terms of safety—offers metaphors for the distance between the two cultures she spans. Shamans are said to be able to fly. Marilyn Bridges can; she does so "from a witch's distance," as John Szarkowski once put it—as low as 200 feet. In a kind of spiritual surveillance, she "keeps an eye on" those values that our own society is in danger of forgetting.

From the air, Bridges says, ancient and new become alike—marks on the earth; marks made by nature and marks made by humankind can merge. Unlike England, where virtually the entire island has been remodeled by human occupation, the American landscape still combines nature and its double human history—before and after colonization. The marks, intentional or random, reveal the symbolic nature of man's relationship to the landscape. "Man creates his models as a result of his life on the surface of the planet," Bridges says. "They are a reflection of his relationship to the landscape. Primitive man manipulated the landscape, but an impression of harmony emerges from his attempts," while modern man's manipulation imposes forms "with a generalized scorn for the equilibrium that engenders harmony in nature." In her photograph "Navaho Hogan," the rounded human shelter is miniaturized by a looming rock that resembles a giant hand reaching into the sky.

Bridges appears to achieve the frame of mind, or altered state, approaching that of the sites' creators: "There are moments when I seem to have reached beyond everyday experiences and found a balance of emotional, intellectual, spiritual, and physical energies. It is at these times that I feel most creative. Flying lifts me into this state almost instantly." It has taken her some time to "learn to see from the air," to develop the fusion of breadth of vision and narrowness of view necessary to clarify such a large and varied scope. The viewer, in turn, must "get used to looking at a landscape perceived from an unaccustomed perspective, which also suggests a reevaluation of attitudes and ideas." Like a traditional Chinese landscape painter, Bridges offers a multidimensional view; like a Navaho sand painter, she is unfettered by static viewpoint, or "right side up." This freedom might be seen as a metaphor for the power (so often abused) of modern humankind to see nature from every angle—from satellite surveillance to remote sensing that penetrates below the surface of the

earth. Such ability should guarantee a wiser approach to the planet. So far, it hasn't.

Process, and practice, are crucial elements in Bridges' photographic product. Aerial photography is poised between science and art, map and picture. It sheds new light on known terrain, and Bridges sees herself as an explorer. She is not interested in mapping or accuracy of terrain per se. "When I photograph," she says, "my focus is seldom confined solely to concrete subject matter, but rather to the concrete as well as illusive matter, which is light itself. . . . Often the light dictates to me the angle at which to bank the aircraft and capture both the positive and negative structure of my image. I tilt the camera at a slight downward angle as the plane bows before the subject matter. This position enables me to cheat reality and bend the light."

When she began to photograph from a plane, in Peru in 1976, Bridges was looking for a way to give body and life to the extraordinary Nazca lines and images, though many photographers would have been satisfied with stark flatness. Despite the fact that aerial photography is above all an abstracting device, Bridges manages to hold the scale of her subjects at a place where they are still wholly comprehensible as physical entities. The distance is never so great that they are diminished by inclusion in and unity with the surrounding topography. In her preference for the dense but raking light of early morning and late afternoon, Bridges found an experiential parallel to our notions of "the dawn of history" or "the twilight of civilization."

Walt Whitman, traveling west by railroad, saw "distances joined like magic." Photography, like the railroad, has been an active agent of the transformation of nature into culture.[1] Aerial photographs can be seen as the ultimate colonization, uniting the hidden fragments of history into a culturally manipulable, but also valuable, whole. "My photographs often present opposing and complementary elements," Bridges has said. "The past in relation to the present, and vice versa. It would be marvelous if, through their visual experience, the viewers saw at least that attitudes must be modified in order to rediscover this harmony. I would like to emphasize the necessity of greater efforts to preserve the archaeological sites, often destroyed by vandalism, or for profit. In this sense my photographs are also documentary—visual records of these sites in case they are destroyed. By maintaining the relationship between tone, shape, and texture, the gesture evoked by the symbolic nature of the subject is reinforced."

While it takes a whole sequence of ground-level photographs to

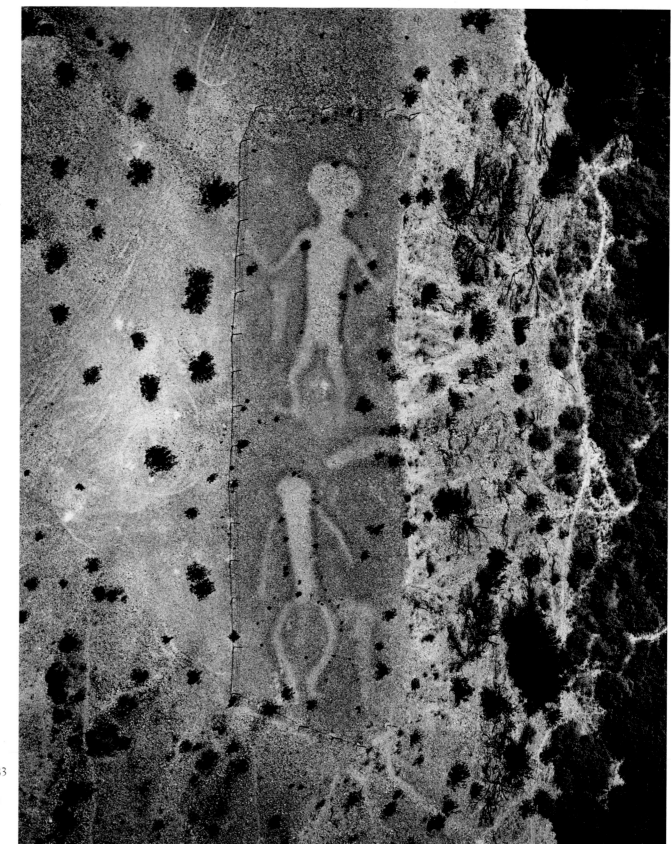

FORT MOJAVE TWINS
Fort Mojave Reservation, California/Arizona, 1983
These two 500-year-old anthropomorphic figures
are intaglios created by removing surface pebbles
to expose the lighter undersoil. The top figure
is 75 feet in height and the lower figure slightly
smaller because it has been ritually decapitated.

communicate a journey, Bridges can do it in a single comprehensive shot of Monument Valley or the Badlands because of her dialectic of aloofness and intimacy, knowledge and speculation. Anna Sofaer's research on the perfectly aligned Great North Road from Chaco Canyon in New Mexico suggests that it may be the "vision of a long-lost world, far from the parched high-desert country." The Chaco people came from the north, and this may have been the road of emergence from the other world, the life road, beginning and ending with Pueblo Bonito and the distant peaks of the La Plata and San Juan ranges, visible from the edge of the abyss where the Great North Road ends.[2]

Much has also been surmised about the reasons for the prehistoric geoglyphs, from the Nazca lines in Peru to the enormous figures and symbols drawn in the southwestern desert of the United States. It has been speculated that the effigy mounds in the Midwest—giant pictures of a bear, a turtle, an eagle, and especially of snakes—were originally very simple sinuous lines composed of "spirit and material, internal and external elements. . . . Later, as life became more complicated, [the snake] needed a large rock for its head and small rocks at its tail. Finally, after the Europeans came, it was not complete without a tongue."[3] This increased literalness (if indeed it did happen that way) diminishes the multisymbolic facets of an image. A "sinuous line" in much indigenous art is not only a snake but also a river, a rainbow, a journey, a lifetime. Bridges' photographs of snakelike western dancing grounds, beaten into the land over perhaps hundreds of years and in use until a hundred years ago, recall the White Horse of Uffington in England, perhaps orginally a dragon/snake marking underground waters, the unconscious of a race.

Explanations for these geoglyphs range from extraterrestrial visitors to terrestrially imagined gods. Yet as anyone who walks a great deal in the landscape knows, there are ways of perceiving topography that are kinetic rather than directly visual. One can sense, through movement and the relationship of body to land, a pattern that is transmitted to the brain as an image without ever being seen as a whole with the eye.

Recently, and belatedly, it has been noticed that there is an inherent racism in the way archaeologists and historians have failed to credit indigenous North Americans with the building of huge cities, massive ceremonial complexes, and accurately aligned earthworks. "Our" Indians were supposed to be simple folk. Perhaps it was less guilt-provoking to move them because they supposedly lived "ephemerally." As Barbara Novak has remarked, Indians represented nature, not culture, to the European colonists and their artists; separated from nature, they died, like felled trees.[4] Yet they did not die. They survived, through a culture stronger than suspected—a culture that has increasingly influenced that which was to have vanquished it.

The revival of "primitivizing art" in the white art world is one sign of this; more positive is the way the varied contemporary Native nations are reaffirming their own histories and the artists are obliterating the homogenized "Indian" stereotype. The renewed respect among a number of white artists, not only for these ancient cultures but also for their heirs has led them into an area between art and science related to archaeology, anthropology, history, environmental politics, and back to art. At the same time, no Native American artists I know of are making art that imitates the ancient earthworks and geoglyphs, or even photograph them. Perhaps it is sacrilege, or unnecessary. Perhaps it is a matter of economics and opportunity. Probably it is more complicated. As French Cree/Flathead/Shoshone painter Jaune Quick To See Smith has observed, the massive absorption of Native imagery into white "primitivizing" art makes her sad, "because it's material we could be using. White artists can be objective about it, where Indians are subjective and not exactly sure how to draw on their backgrounds because they are so much closer."[5]

Bridges and a few other photographers are particularly concerned with the traces on the earth of ancient cultures and the social pressures that frame them. Steve Fitch has concentrated on rock art—the petroglyphs that, like Bridges' geoglyphs, are rooted in their place and have resisted the fate of collectible objects (even those like grave dolls, mummies, whole tombs, which should never be taken out of context). He says that these rock and earth arts are sites melting into places "integrally enclosed within a number of contexts, like something placed at the center of an expanding series of concentric circles."[6]

Bridges' photographs in this North American section remind us of the immense variety of ideas and forms that were created by the numerous and equally varied cultures on this continent. We are just beginning to be aware of their ubiquity, which struck me in full force a few years ago when I was touring the mounds of Licking County, near Newark, Ohio; despite the expertise of my guide, we stumbled on yet another unmapped mound. In Europe, Asia, and South America stone rows and circles, mounds, pyramids, embankments, dancing grounds, and enclosures are being unearthed every-

where, or merely noticed just before they are destroyed by ignorance, carelessness, malice, or greed.

Bridges' work raises disturbing contradictions not only about modern attitudes, and the social manipulation of the land and its history, but about the veneration of indigenous peoples' pasts while we destroy their futures and refuse to respect their present. As the helicopters of corporations and the federal government circle the Hopi-Navaho reservation at Big Mountain, sheep die, and lands dry up, and the twentieth-century version of the cavalry zeroes in for another try at genocide. When asked if her photographs had a message, Bridges replied: "There is a message linked to my attitude, but I don't shout about it. My goal is also to make photos that will please those who look at them. However, I have the impression that in breaking harmony with nature, modern man is destroying his own environment. Primitive man comprehended, intuitively, the rhythm of the forces of nature, and how to accommodate himself to them. In order to survive, we must recover that knowledge." This may be difficult if we erase the culture of those who have inherited it. The Hopi elders at Big Mountain are patient. They say the life forces will win in the end.

Terence Pitts asked about Bridges' photographs, "To what extent do our responses become confused with our responses to the content?"[7] This response in itself epitomizes the separations imposed by Western society. Is there any reason why the forms should not be fused (rather than confused) with the content and symbolism? That is precisely what Bridges at her most successful manages to do. Thanks to her location above and within her sites, she communicates those elusive moments of recognition when she has inherited something of the spirit of the places she "takes"—a spirit she courts with courage and commitment.

LUCY LIPPARD

Quotations from the artist come from press releases and an interview (published in French and translated by myself back into English) in *Clichés*, February 1985.
1. Barbara Novak, *Nature and Culture* (New York and Toronto: Oxford University Press, 1980), p. 184. 2. Letter from Anna Sofaer, Solstice Project, 1986.
3. Felicia Murray, unpublished notes on Marilyn Bridges. 4. Novak, op. cit., p. 189. 5. Jaune Quick To See Smith in *Women of Sweetgrass, Cedar and Sage* (New York: Gallery of the American Indian Community House, 1985), unpaged.
6. Steve Fitch, unedited manuscript for forthcoming book on rock-art photography project (Albuquerque: University of New Mexico Press). 7. Terence Pitts, "Tracings of Power," *Artweek*, December 3, 1983.

DANCE PATTERN #3, Imperial County, California, 1983 This irregular Paleo-Indian snake dance
pattern was created by dancers who stood side-by-side and moved in a regular sequence. The pattern is
nearly three-quarters of a mile long and six feet wide and may have been in use for thousands of years.

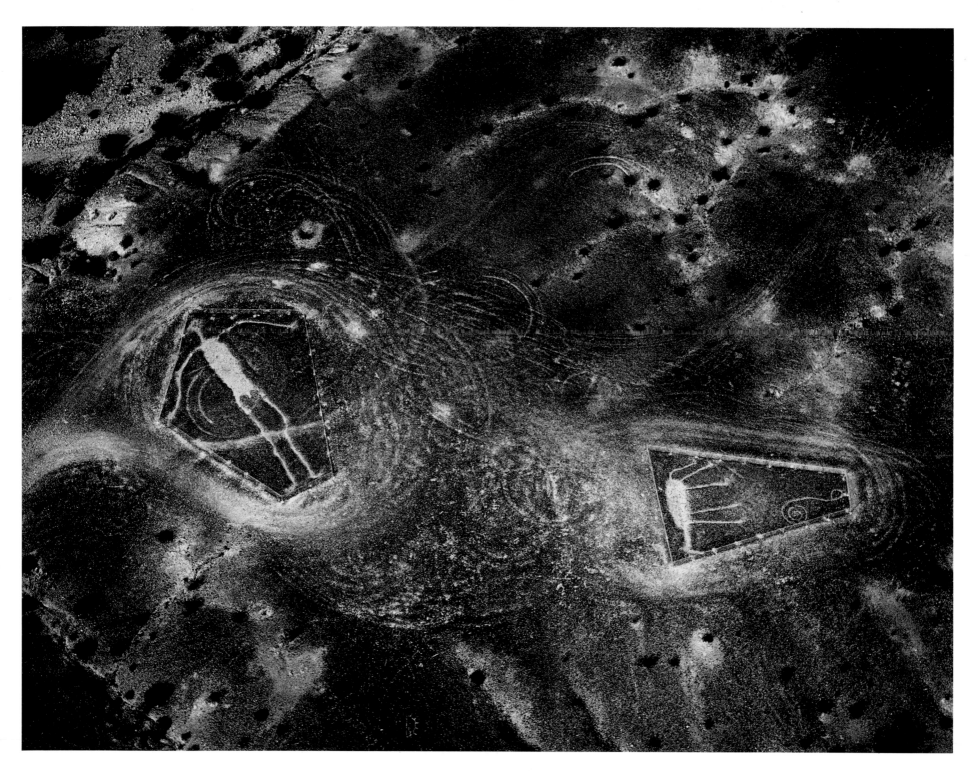

OVERVIEW, Blythe Site # 2, California, 1983 This is one of three Blythe intaglio sites. Here, a male figure
some 94 feet tall is said to represent Iitoi, protector of the Pima-Pagago people. It may be 500 years old. Note the trace of a dance
circle that crosses the knees and travels around and above the figure. The animal figure, some 36 feet in height, is believed to represent Numeta,
the mountain lion that accompanies Mastamho, the Mojave creator god. The spiral is 16 feet across and resembles a Hopi migration symbol. 61

TWEED FIELD, Le Roy, New York, 1981

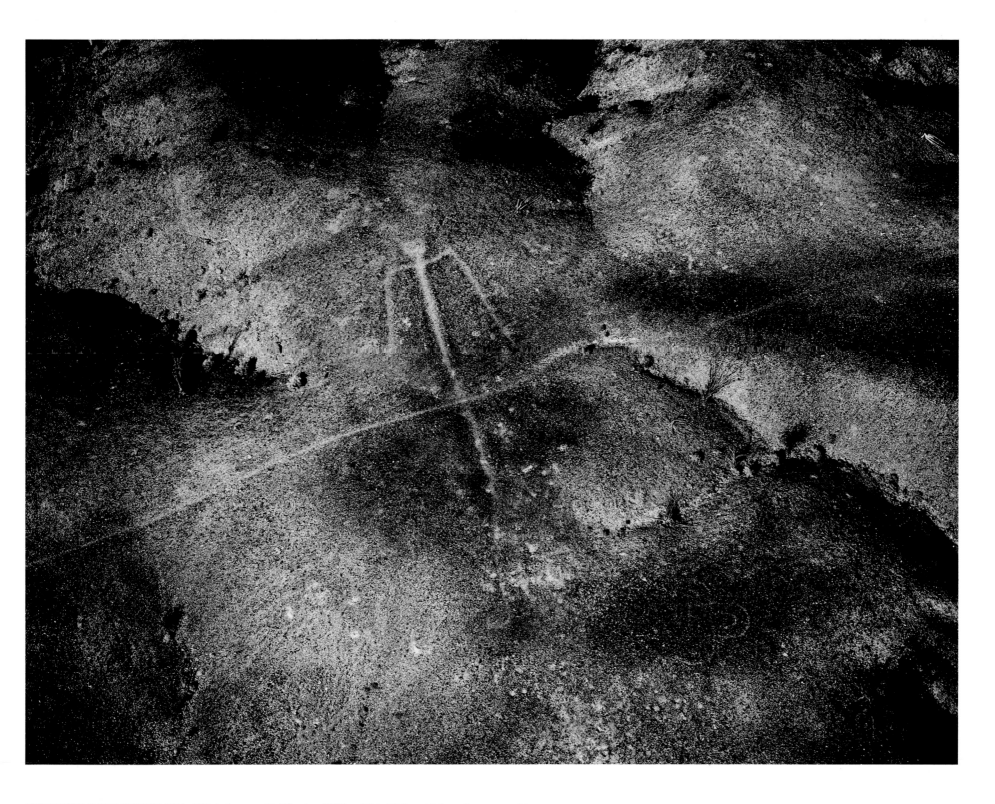

WINTERHAVEN-STICKMAN, Winterhaven, California, 1983 This 80-foot-high anthropomorphic
figure is said to represent a mythological monster in Mojave lore and might be 500 years old. The interwoven
cross below it is a likely healing site—its four arms representing the four cardinal directions.

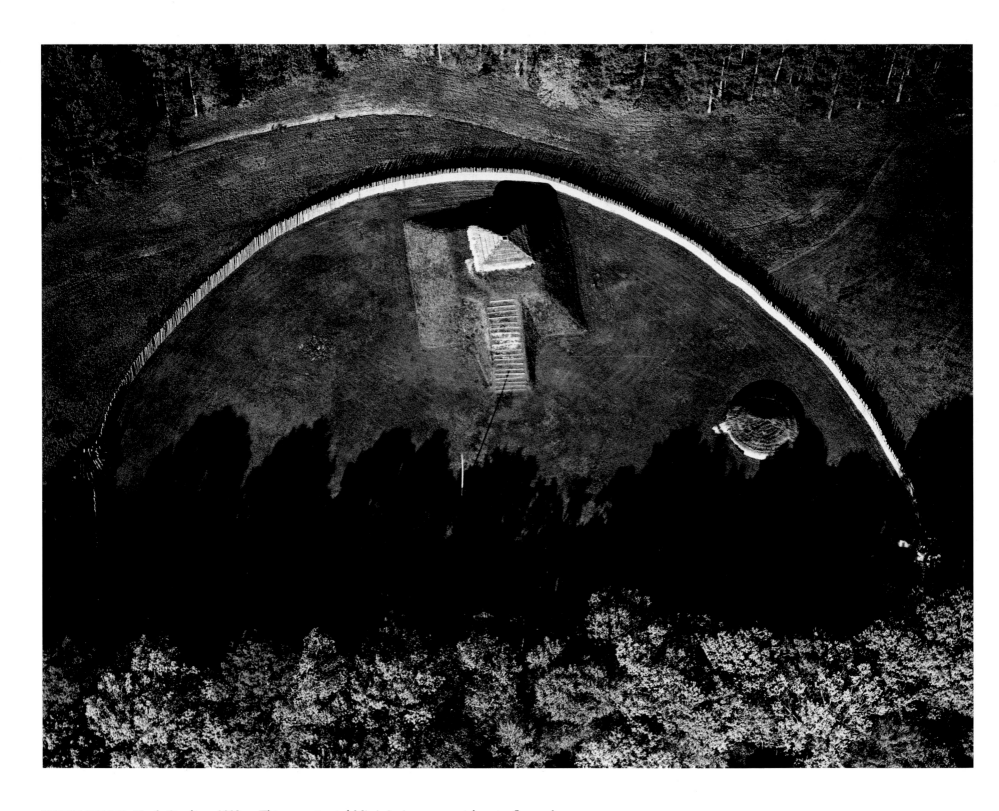

TOWN CREEK, North Carolina, 1982 This reconstructed Mississippian ceremonial center flowered
between A.D. 1450 and 1650. Notable features include a protective log palisade, a truncated pyramid (rising some 17 feet from an
86-foot-square base) and a 35-foot earthen ramp that leads from the plaza area to the top of the pyramid.

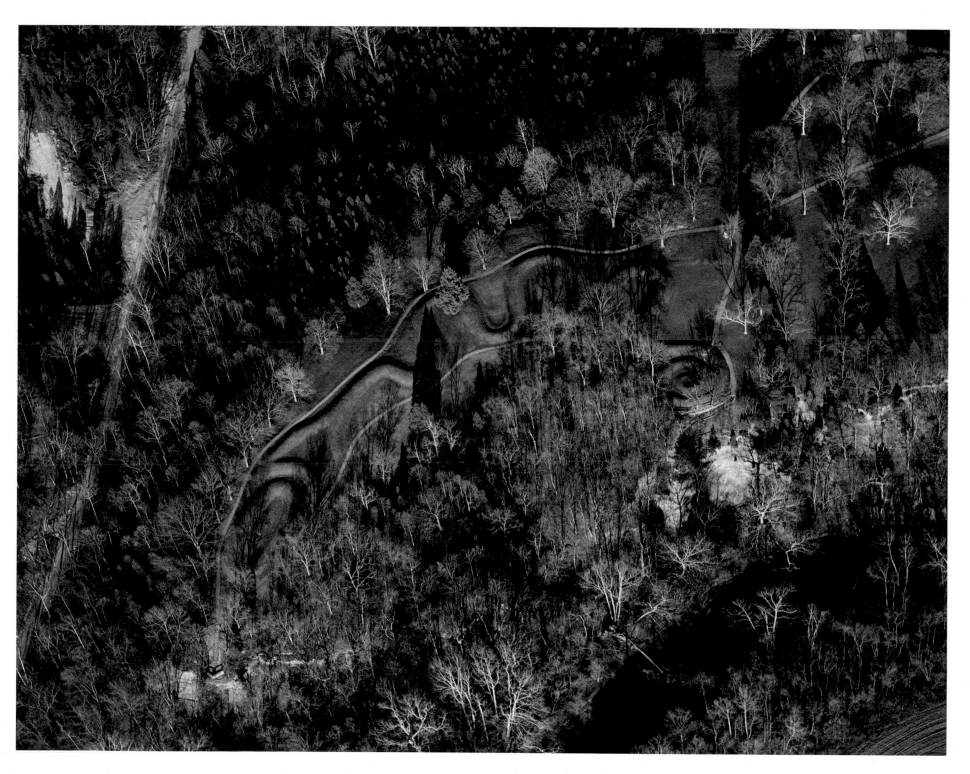

SERPENT MOUND, Ohio, 1982 This largest effigy mound in the United States is an embankment of rocks, earth, and clay over 1,300 feet in length, some 20 feet wide, and four feet in height, and was built by the Adena people between 1000 and 300 B.C. Its open jaws are about to seize an oval object (a slightly elevated earth mound some 158 feet long and 79 feet across), said to symbolize an egg.

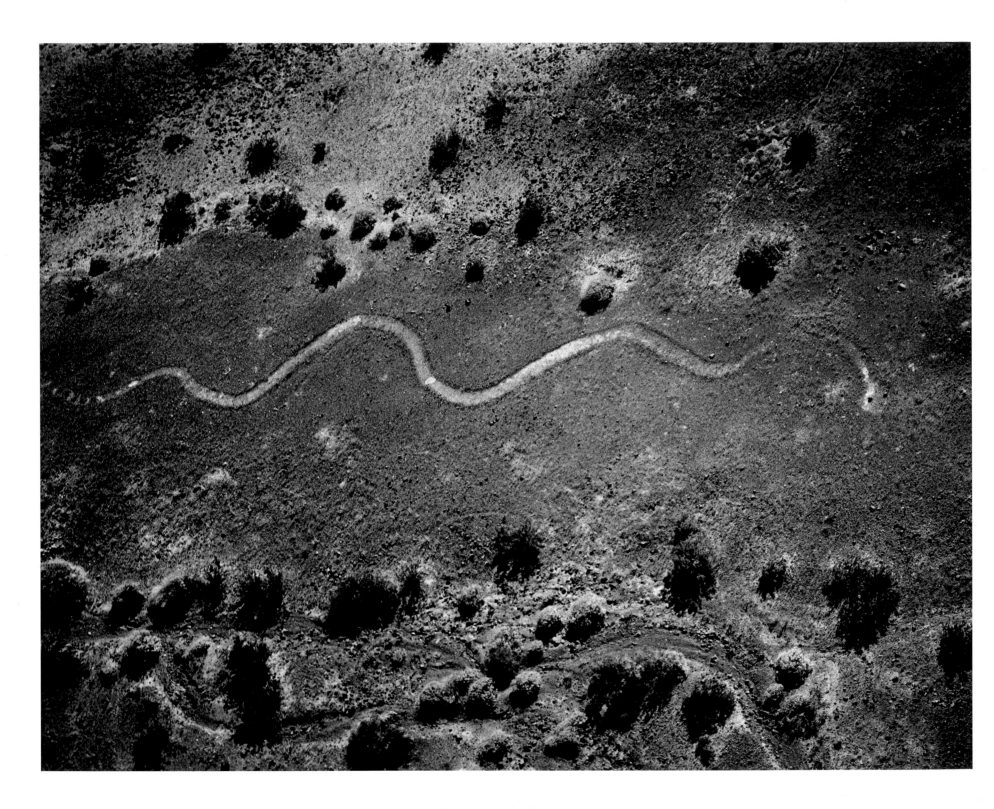

PARKER RATTLESNAKE, Parker, Arizona, 1983 This 165-foot-long serpent has been rendered realistically with a forked tongue. Although an intaglio, several sets of stone rattles and two quartz eyes have been provided. It is believed to have been made by Mojave shamans about 200 years ago.

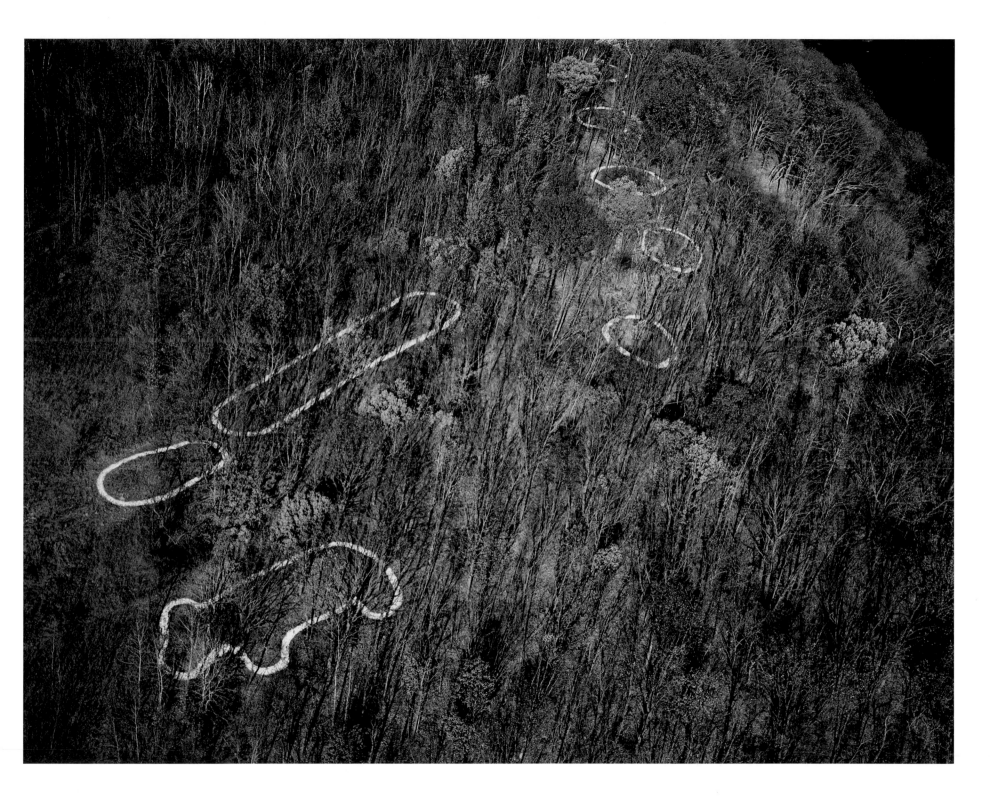

BEAR, LINEAR AND CONICAL MOUNDS, Iowa, 1983 Around A.D. 650 the practice of molding earth into effigy
and geometric shapes became a religious cult in areas of Iowa, Wisconsin, and Minnesota. All average 3 feet in height, some
70 feet in width, and about 100 feet in length. The mounds in the photograph have been outlined with agricultural lime.

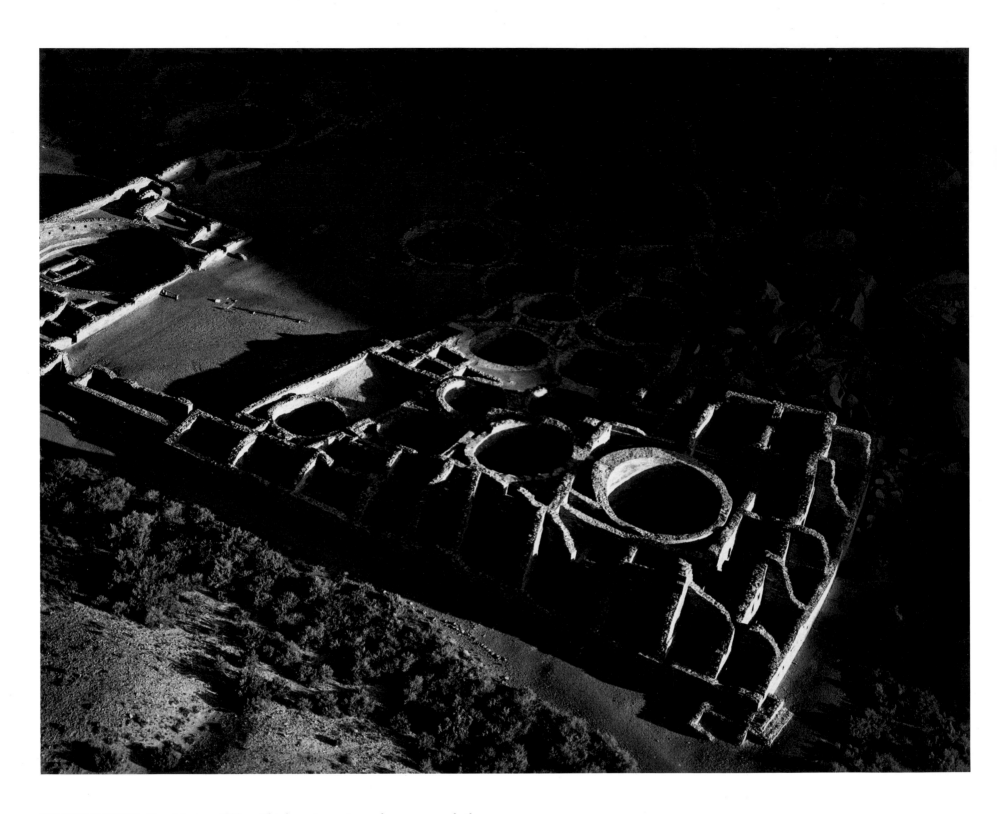

PUEBLO BONITO, New Mexico, 1983 This large Anasazi complex covers nearly three acres
and contains 600 to 800 rooms. At its outer wall it was four stories high. Begun in the ninth century,
it became between 1050 and 1130 the largest and most complex building in the Anasazi world.

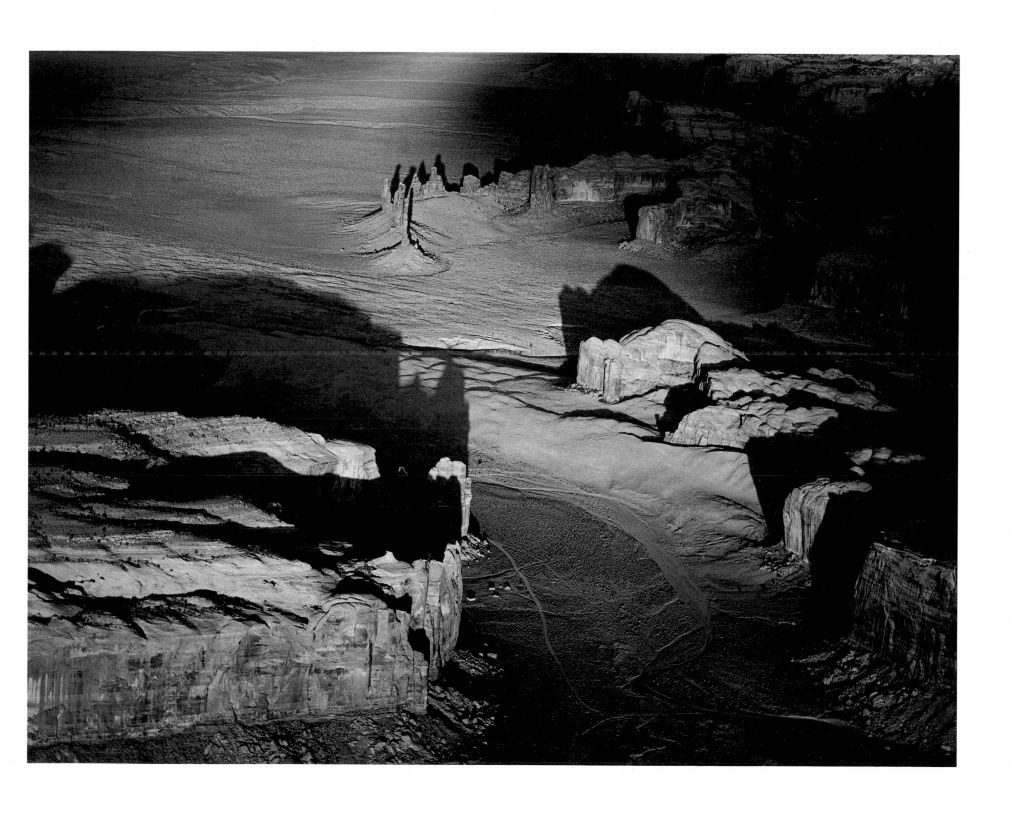

JOURNEY, Monument Valley, Arizona/Utah, 1983

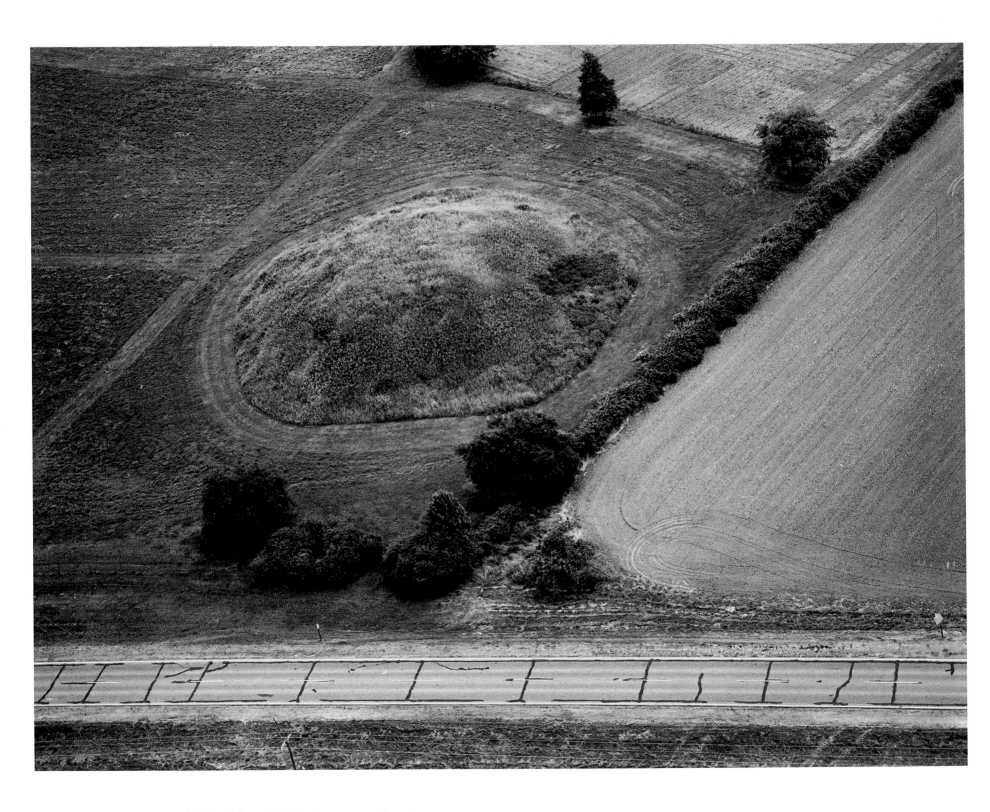

WINTERVILLE, Mississippi, 1982 A large Mississippian ceremonial center
that flourished between A.D. 1200 and 1350, Winterville has 17 recorded mounds. The grass-covered
mound in the photograph probably served as a platform for the house of a prominent person.

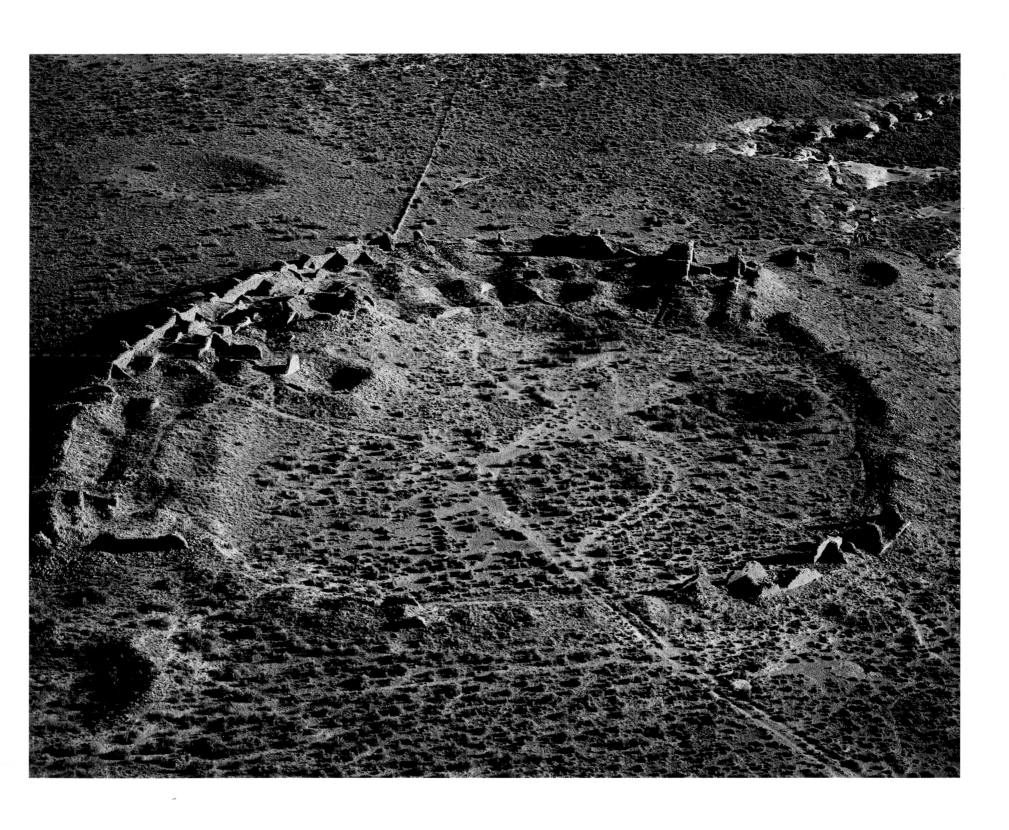

PENASCO BLANCO, New Mexico, 1983 Unexcavated ruins of a large Anasazi Chacoan complex
believed to have been started around A.D. 900, with major construction between 1050 and 1088.

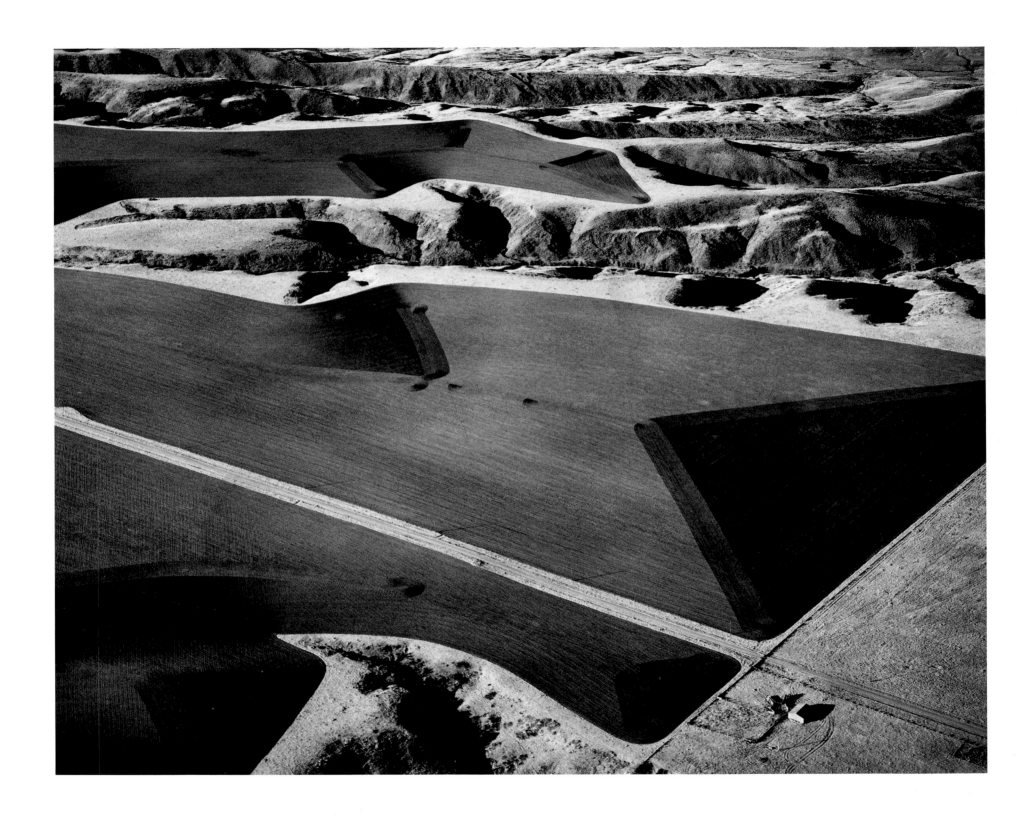

FARMERS' EDGE, THE BADLANDS, South Dakota, 1984

ICE FORMATION # 2, Quaker Pond, Mendon, New York, 1985

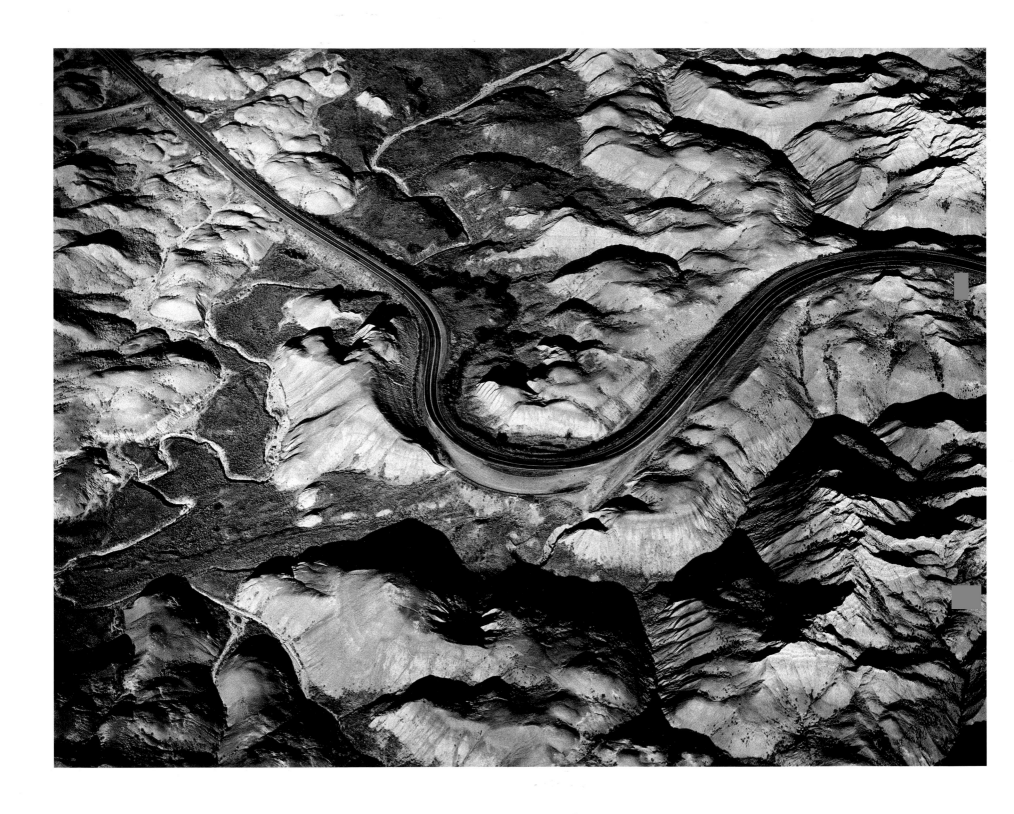

SNAKE ROAD, THE BADLANDS, South Dakota, 1984

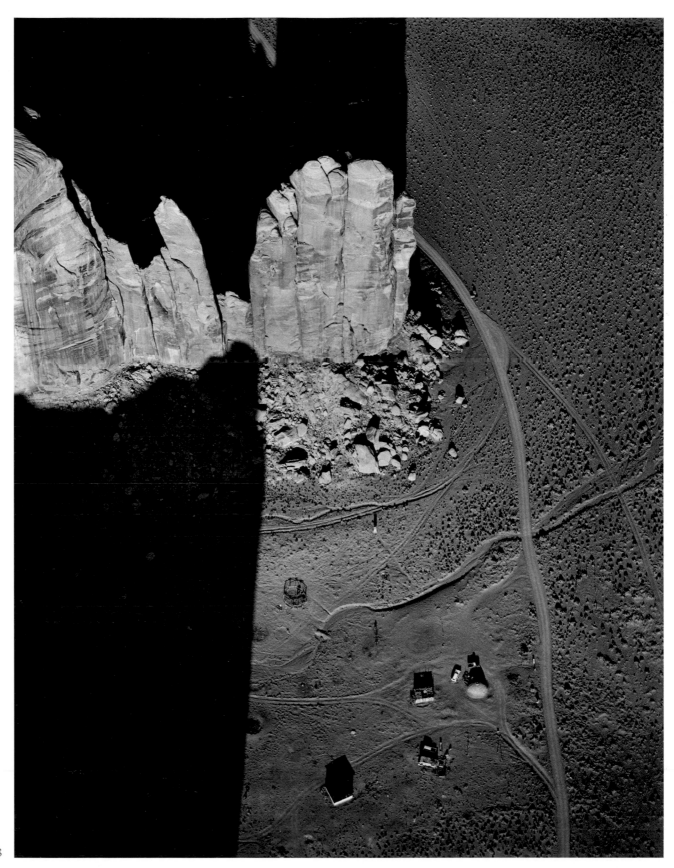

NAVAHO HOGAN,
Monument Valley, Arizona/Utah, 1983

BRITAIN AND BRITTANY

The mystery of permanence within the changing world will always engage the human mind. Oneness is permanent; one of something is not. Time is the natural experience of change, because without change there would be not time.

Yet photography performs that near miraculous act of stopping time, freezing the moment in a split second of the shutter. We know it does not really stop time, but it does give us a remarkable insight into the idea of timelessness or eternity.

The Great Pyramids, Stonehenge, and the Great Wall of China are often regarded as the supreme symbols of permanence in the life of humanity on this planet, yet Silbury Hill, the great earth pyramid outside Avebury in southern Britain, not only in its own way equals these feats of construction but is now believed to be older than all of them. It was presumably the local observatory for a very sophisticated priest/astronomer/scientist caste of the time. Avebury itself is one of the world's largest stone temples—an indication perhaps of the size of the population that assembled at this sacred site—and, according to the late Professor Alexander Thom,[1] the greatest surveying accomplishment of the Neolithic era.

Who were the builders of Silbury, Avebury, Stonehenge, and the like? There is no doubt that they were our ancestors, who in their concerns for the permanence of the cosmic cycles established monumental temples. Evidence of centuries of accumulated knowledge of sun and moon rhythms and the recurrences of planetary positions indicates that these early Britons developed quite astoundingly sophisticated methods for reading the skies. Professor Thom gave evidence of a precision in astronomic sighting that would tax even the most modern team of surveyors with today's technical instruments.

Although little is known about ancient Britain, calculations indicate that it would have taken the whole of the known population decades of full-time work, with the bone and stone tools known to have been used, to achieve the largest standing stone circles at Stonehenge. But what do we really know of those remarkable predecessors of ours? Physically we know them by their monuments; psychologically we can deduce that they were motivated by an intensely sustained conviction not only that there were permanent values in an orderly cosmos but also that these should be evoked, re-created, and studied in monumental form. Why else would a society dedicate all its surplus economy to moving so much earth and stone?

Here is the paradox neatly juxtaposed. In her iron bird Marilyn Bridges has captured with her mechanical eye the timelessness of the great British earth monuments, which have been standing for nearly five millennia, in a fraction of a second. From a part of the heavens previously inhabitable only by angels and gods, we are given evidence of the power of centuries upon centuries of duration and mystery through a light-sensitive mechanism that holds precise images of a blink of time.

When one sees maps of certain parts of Britain marked with the neolithic and early Bronze Age monuments, tracks, and markings, one realizes how extensively and densely these islands were covered. It is clear that Britain was inhabited by an early human culture with its own science, which did not have written numbers or words but was based on the art of memory developed to a degree undreamed of by modern man.

AVEBURY

Alexander Thom was Britain's leading authority on megalithic science and the geometrics of the ancient stone circles. His view of the great Avebury enclosure and stone circles is that its near destruction was "perhaps one of the worst acts of vandalism in recent centuries." Yet with the help of Alexander Keiller he reestablished the diameters and positions of the older circles inside the main ring, using careful astronomical determinations. The results led him to believe that there was "sufficient accuracy" in this survey to verify his lifelong thesis of the existence of the megalithic yard of 2.72 contemporary feet.

Thom believed that the origins of the vara—or yardstick—lay in the megalithic period. The later measures, though many thousands of years apart, give the following close values for the vara: Burgos, 2.766; Madrid, 2.7425; Mexico, 2.749; Texas and California, 2.778; Peru, 2.75.

However, the astounding indications of continuity of the most ancient of human science/cultures are such that Avebury, dating back to at least the third millennium B.C., has the megalithic yard so intrinsically embodied in its determining geometry that Thom demonstrates that no fewer than six arc radii, together with all three sides of the inner forming triangle, and no fewer than seven more significant dimensions all turn out to be in whole megalithic yards. Nowhere is the outer stone ring less than 2000 feet in diameter, and whole village communities and farms survive within its boundaries.

Avebury's geometry is, like so many of the megalithic circles, founded on the Pythagorean 3, 4, 5 triangle, in this instance in units of exact 25 megalithic yard lengths, 75, 100, and 125 each. What is characteristically understated by Thom is that here is the Pythagorean triangle in use a millennium or more before Pythagoras lived. Because there is no written (abstract) evidence left by this megalithic culture, archaeological scholarship has tended to deny the intellectual feat. However, the evidence is in far more concrete form in the stones themselves—just as the mysterious phi dimension ϕ is embodied in the Great Pyramids in Egypt. As if Thom's first discoveries of the use of the megalithic yard were not enough, analysis of the six determining arcs

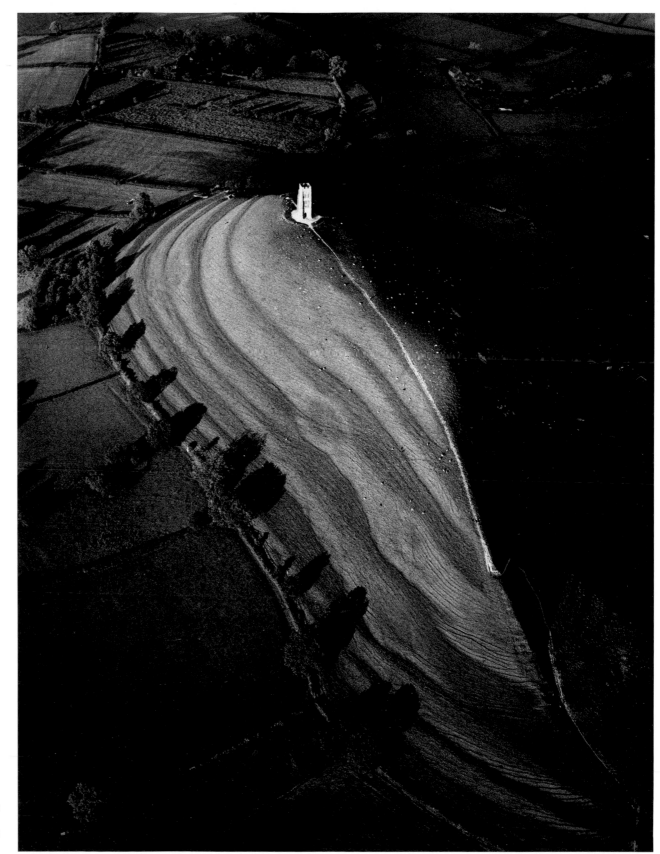

GLASTONBURY TOR, Somerset, 1985
On the Tor's summit are the ruins of
St. Michael's Church, said to be built on the
remains of a pagan temple. The hill's ridges
may be the pattern of a ritual spiral path that
circled the hill seven times to the summit.

further revealed that all six were in submultiples of two and a half megalithic yards, a fact that Thom called "a rule which we have seen is almost universal for perimeters [of the stone circles of Britain]." Finally, to demonstrate why Avebury was so important in size as well as intrinsic geometry, Thom believed that the megalithic builders left monumental evidence of their understanding of π (pi the transcendental). He instanced two smaller inner circles of Avebury, both 340 feet across; taking pi at 3.14, the circumferences become 392.5 megalithic yards, again a multiple of 2½. This embodies, as Thom said, "one of the best rational approximations to π (pi) left to us by these people."

Alexander Thom's findings are still considered so radical and challenge so many current conventional archaeological beliefs that there is still much resistance to his concrete evidence. Most significantly, he challenged the whole concept of writing = intellect, and demonstrated the importance to ancient man of being geometrically in tune with the cosmos.

BRITAIN: THE LANDMARKS

Since earliest recorded time Britain has been landscaped like a work of art, from the imported skins of soil brought overland from the Continent by the beaker people to the work-of-art farms of Tudor times. Brought up on the monastic masters of agriculture, the British landscape is a sensitive body resulting from generations of care, attention, and earth wisdom. This last concept does not come easily to the modern exploitative way of thinking, not least because there is no word in modern English for wholeness in the particular sense of plant, animal, and human relatedness. We have had to import the word *Gestalt* from the German and, more recently, invent "holistic" and "imaginal." Earth wisdom was institutionalized in most past civilizations in the agricultural policies that were the basis of their existence. In ancient China and Japan this was extended to become *Feng-Shui*, which misleadingly translates as "wind–water," or the elaborate science of siting. The first principle of this ancient discipline was to ensure that the blessings (from warmth to fertility) of Heaven were integrated with the receptivity and motherhood of Earth. The responsibility of mediation was that of humanity as the husbandman, priest, and guardian but, above all, as conscious appreciator of the miraculous necessity of the marriage of Heaven and Earth.

What is so powerfully evident from Marilyn Bridges' aerial images is that we are being given an angel's-eye view, the view of the gods. The constructions on the ground offer images to the heavens made by those who understood the vital necessity of maintaining contact with the heavenly lights, the heavenly intelligences, and the unnamable Creator as the principle of unity itself. Yet the angels have been virtually banished by the modern world.

What do we really mean when we talk about the "laws of nature"? Are we not rather obviously giving nature intelligence? Otherwise how could we talk about the unchanging universal conservation of energy, or about gravity or the profound consistency of atomic numbering and behavior? Gravity is an invisible force that acts upon mass but is not itself mass; atoms are characterized by number but are not themselves number. Could we then be unintelligent enough to suggest that these consistent universal coherencies are *without* intelligence? If we do, then we have to take care to define our own meaning and use of the word "intelligence." Measure is the fundamental tool of empirical science, but measure and interpretation are two different things. Intelligence, as we understand it, works invisibly through things, in things, and on things, but it is not itself a thing, and the laws or principles of nature do likewise.

What is the essential difference between these heroic folk of old who literally moved mountains (Silbury Hill and the giant stones of Avebury and Stonehenge) and ourselves? For all the improvements in life expectancy, comfort, technological gadgetry, speed of transport, and so on, are we essentially wiser about the meaning and quality of life? And are we wiser about our own relationship with heaven and earth? For all the constant emphasis we place on progress, Paul Radin, the distinguished anthropologist, summed up another perspective admirably when he said, "No progress in ethnology [the study of humankind and its differences] will be achieved until scholars rid themselves once and for all of the curious notion that everything possesses history, until they realize that certain ideas and concepts are ultimate for man."[3] "Progress in what?" was also the question of E. S. Schumjacher, who also reminded us that we need to be clear when we use the word "science"—*which* science? There is the science of understanding (which Paul Radin is obviously referring to), and there is the science of manipulation, which implies change in technique for its own sake with no necessary thought of the ultimate consequences. The first is a progress in wisdom, the other in technology.

It is dramatically clear that the great earth movers of what we call prehistory used their own unexplained technology to place stones and earth mounds for quite explicit purposes of orienting to the heavenly lights. They built to read, understand, and harmonize with the great timekeepers of the heavens: the bringers of fertility in the spring, flowers in summer, and the food of fruition in the autumn. All civilizations have been developed in a symbiotic balance between nature and nurture and have created a sufficient surplus to survive foodless periods and allow time to study, to pray, to sacrifice, and to celebrate their understanding of human destiny and the laws of nature.

To return to Paul Radin's perspective of man's ultimate ideas and concepts, we might define the immense power held over us by monuments such as the Great Pyramids and Silbury Hill and the alignments of Carnac in Brittany as being due to the driving force of certainty within the markers—a certainty that convinced them of the absolute necessity of making, keeping, and understanding precise contact with the cosmic rhythms.

If it was ultimate for them, Radin suggests, how can it not be ultimate for us? Passing time is governed by the principle we call

change, just as our changing world is governed by the principle of time. The principle is ultimate; if it changed, then it would no longer govern time.

Geoffrey Russell[4] has put forward good evidence for interpreting the paths on Glastonbury Tor as a spiral. The ritual spiral climbing of Glastonbury Tor is possibly a prehistoric sacred ritual adopted by the early Christians, as it was in Croag Patrick on the west coast of Ireland. This expression of the archetypal sacred mountain as a ritual center of the world is like Mount Meru of the Hindus or Mount Olympus for the ancient Greeks. Most ancient peoples held mountains either to be nearer the gods or to be the home of the gods. The pathlike Way (Tao) of the ancient Chinese symbolized a well-trodden and safe ritual ascent to the rarefied and awe-inspiring domain of the holy ones, or gods. The ancient British choice of living on hilltops was both economically and defensively sensible, but also symbolically appropriate to the position of humanity in the scheme of things.

Large earthworks were sacred either in the sense that they were reminders of sacred beings or principles, such as the White Horse, or as time diagrams, circles, barrows, and so on, each holding the significance that was at the center of things. The Latin *tempus* for "time" and *templum* for "space" come together in their greatest significance in "contemplation."

"The first sanctuary," said Plotinus, "is this earth." Avebury is the largest and, in the expert opinion of Alexander Thom, the most remarkable piece of neolithic planning and land surveying of the great standing-stone monuments in the United Kingdom. And the great menhir and the huge alignments at Carnac are also achievements of orientation and placement rarely equaled anywhere in space or time by human effort anywhere in the world.

Since the work of Thom was released "like a well-wrapped time bomb," as one observer said, new horizons have opened up in our appreciation of societies with unsophisticated technologies yet with elaborate creation myths and complex tribal ceremonial rights and traditions. It is a particularly modern idea to divide human behavior and thought into many isolated departments; most traditional peoples have an overriding principle of unity, although they call it by many and various names. Thom demonstrated time and again that many of the stone circles of Britain are oriented to sun, moon, and star risings and settings with quite astounding degrees of accuracy, and Andrew Davidson[5] has demonstrated evidence for regarding Silbury Hill as a massive sundial that could calculate the precise length of the year.

As the rhythms of the cosmos are constant and the symmetries of space are ultimate, maybe our seeing these remarkable images of our ancestors reminds us of the "frozen moment" that a remarkable photograph can bring—a reminder of another dimension and meaning to our relationship with our natural world.

Once we enter these essential, ultimate, or, we might say, archetypal areas of concern, we find a remarkable parallel with photography—that mute witness that a sensitive eye can make to the world about us. Photography, having chosen a significant place, freezes time into a moment, places a hold on change, frustrates the time that wears away our world, and, if seen with the eye of the heart, can transmit to us the sense of eternity.

Marilyn Bridges, with an exceptional eye for the angles of light, for alignment, contour, and pattern, sees the footpaths, the pylons, and contemporary housing as much part of eternity as the millennia-old stones and earthworks. These primal images are origin reminders both in the sense of human symbiosis with the land and in the architectural sense of the first "recorded" temples.

The word "origin" is intimately linked with the direction east—or orient—through the Latin *oriri*, "to rise," and this, in turn, links it with the fundamental concept of the temple with its orientation to the east and the origin of the day. This is the common ground of the stone circles and alignments. "The path of return" and remembrance, as it is often referred to in certain spiritual traditions, is related to the angles of alignment to the heavenly lights: the sunrises and sunsets, the moonrises and moonsets, as well as the risings and settings of the constellations. Is it we who have forgotten the significance of these angles of incidence of light? What else tells of the season of the day, the season of the year, the season of the era? Is this what the Buddha meant when he told his followers to seize their moment, to grasp their time? Is this the *Kairos* within *Kronos* that the ancient Greeks talked of? That timely moment that cuts through passing time and grants us a momentary experience of eternity? Is this the gateway to a return in the sense of remembering a reality of which we already know?

If the angles of sunlight are the spectrum of time, the triggers of fertility, the signals of all life rhythms, then in what way might they differ from angels? All civilizations that left written records believed in an angelic hierarchy as well as the view that intelligence and light were inseparable symbols. Why should we believe that the vast neolithic civilization of mysterious tumuli makers, stone-circle erecters, stone-sphere carvers, and natural astronomers was not equally aware of the significance of the angles of light—both as shadow casters (gnomons) and, more significantly, as the heralders and bringers of the seasons of birth, growth, maturation, and death? It is the life cycle that is the primal reality of our created world.

Marilyn Bridges' contemplative images give us a chance to recall and dwell on the mysteries of our own situation. We are reminded of the stark facts of our existence. We all know that our actuality is made up of facts, but facts divide, beautiful images unite, and the most complete model of our universe is probably a poem. A poem seen, heard, and to be taken to heart.

KEITH CRITCHLOW

[1] See his *Megalithic Sites in Britain* (London: Oxford University Press, 1967).
[2] See *Henri Corbin on Imagination* (Ipswich: Golgonooza Press, 1976). [3] *Die religiöse Erfang der Naturvolke* (Zurich: 1950). [4] See R.I.L.K.O Publications, London. [5] *Britain, A Study in Patterns* (London: R.I.L.K.O. Publications, 1971).

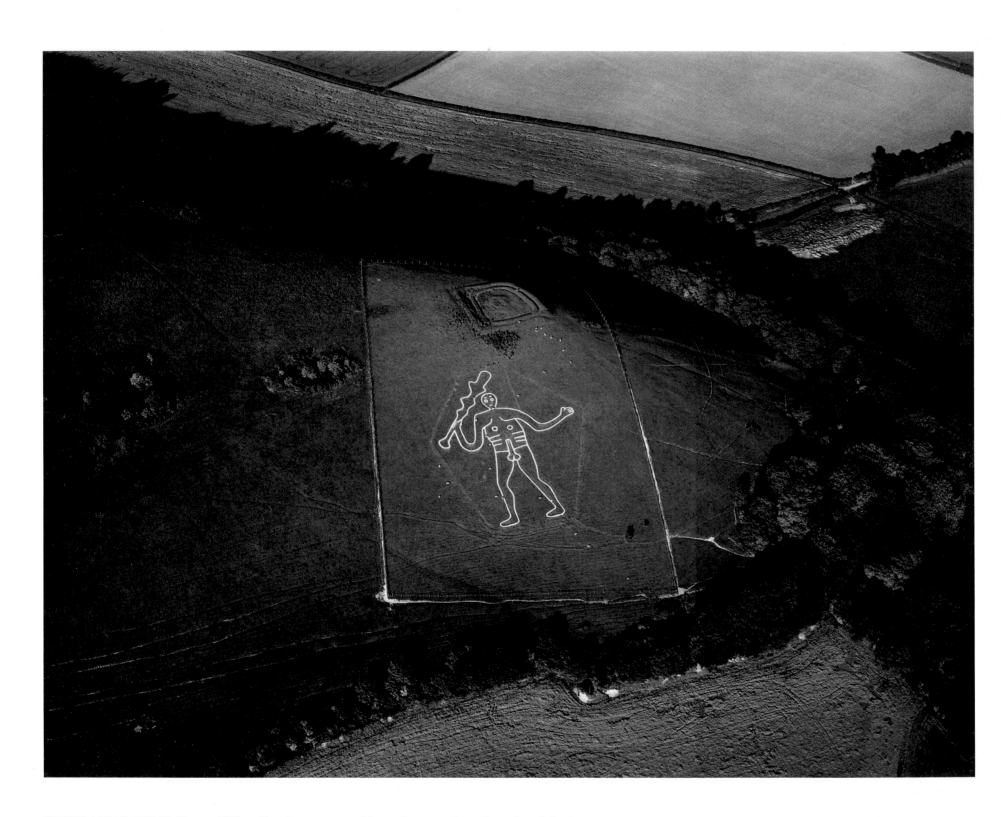

CERNE ABBAS GIANT, Dorset, 1985 The giant was created by cutting away the turf covering of the down
to expose the chalky undersurface. The figure stands some 180 feet tall, with its proud penis 30 feet in length.
It probably dates to c. 100 B.C. to A.D. 200 and represents the Celtic god Helith or his Roman counterpart Hercules.

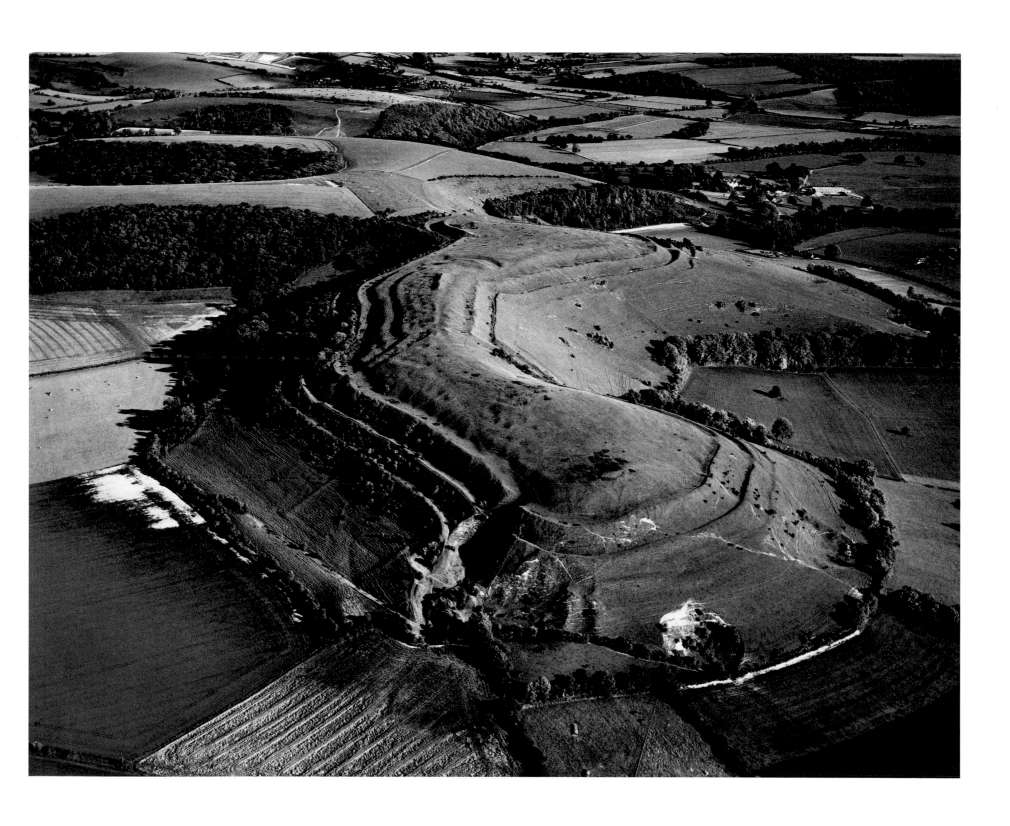

HAMBLETON HILL FORT, Dorset, 1985 This impressive Iron Age
hill fort is encircled by two earthen ramparts enclosing 24 acres.

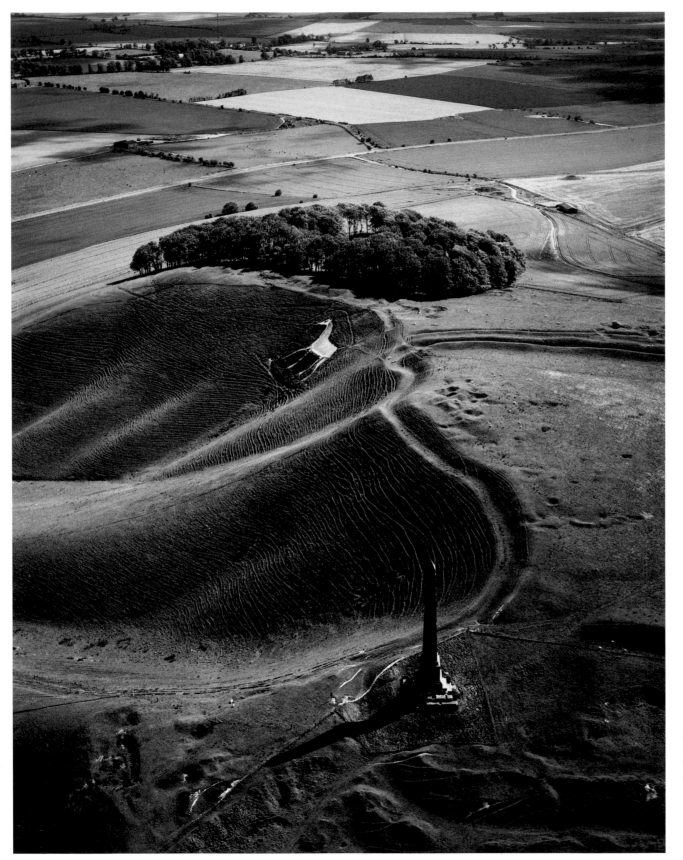

CHERHILL HORSE AND LANSDOWNE OBELISK, Wiltshire, 1985
This chalk equine was cut in 1780 by Dr. Christopher Alsop as a "decoration for the landscape" and measures 131 feet tall by 123 feet in length. On the bluff just above the horse is the Iron Age hill fort of Oldbury Castle. The obelisk (foreground) was erected by Lord Lansdowne in 1845.

82

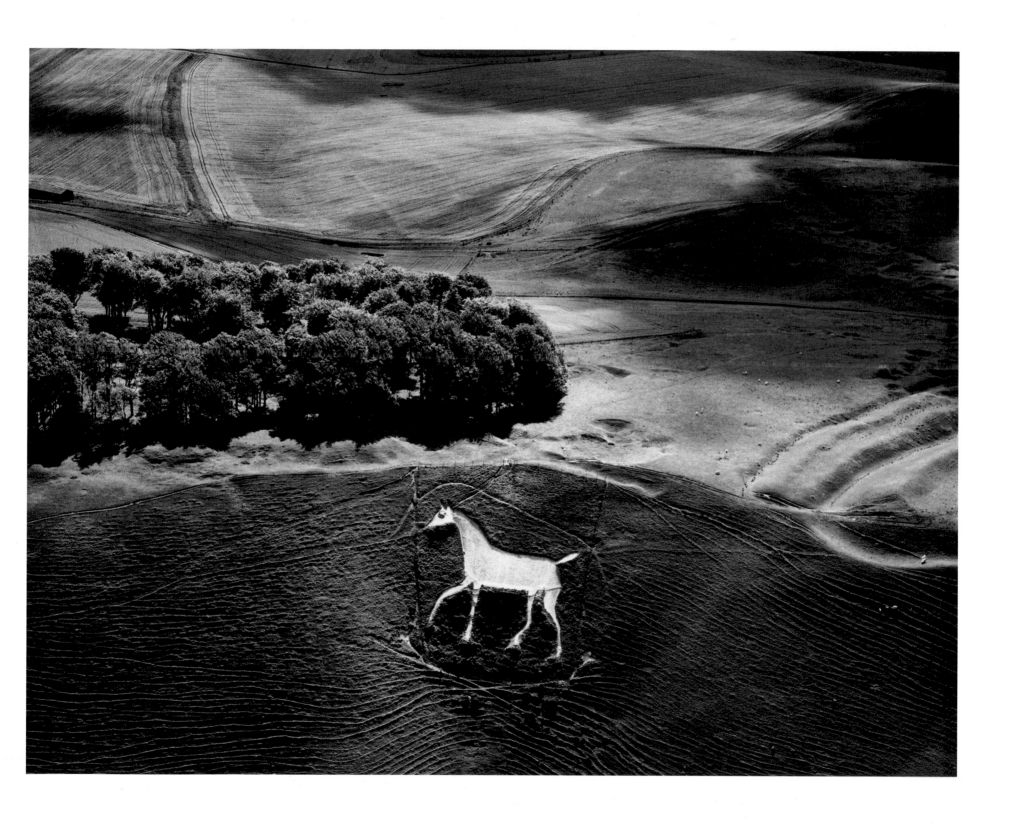

CHERHILL HORSE, Wiltshire, 1985

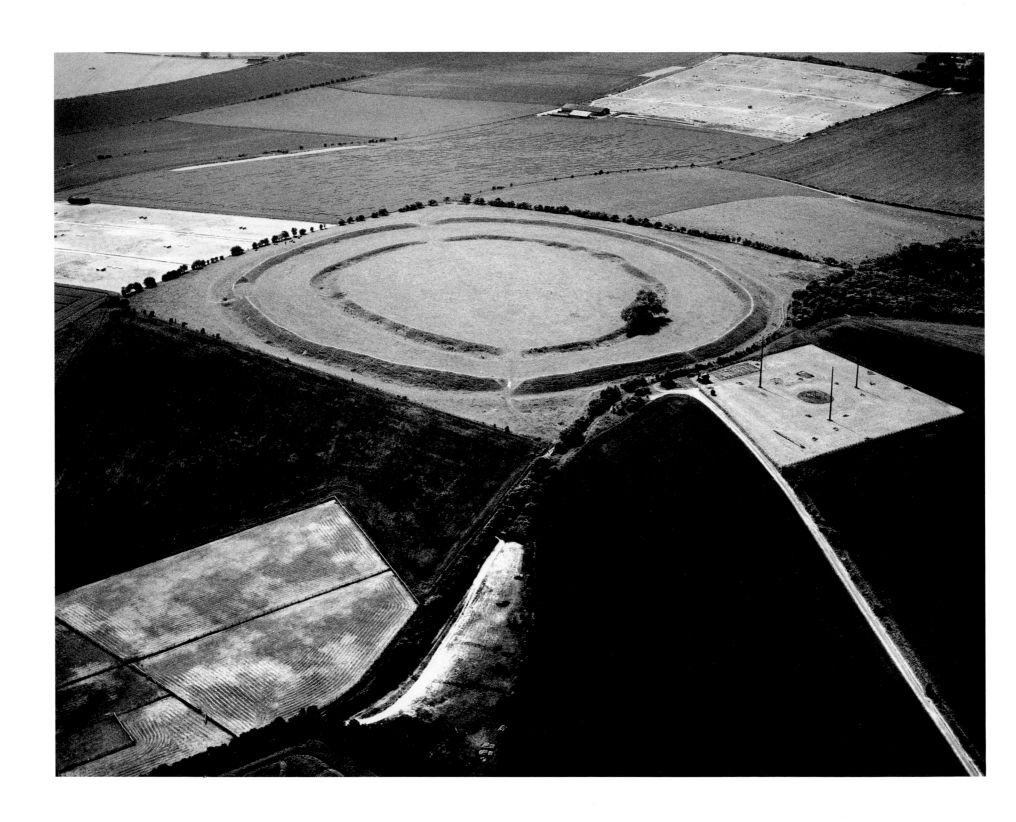

FIGSBURY RING, Wiltshire, 1985 This Iron Age hill fort with its outer ditch
and earthen ramparts covers some 27 acres and has an inner ditch that is unusual for British hill forts.

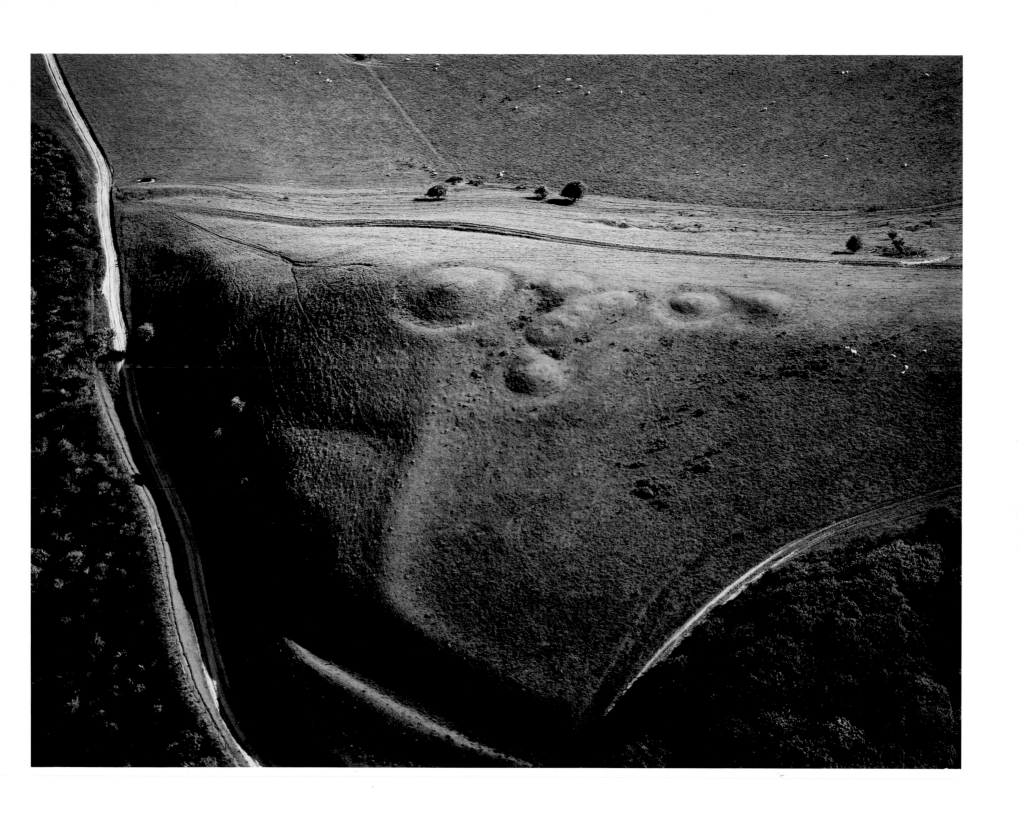

ROUND BARROWS, Wiltshire, 1985 These mounds of earth
erected over the remains of the dead date from the Bronze Age, c. 2000 to 600 B.C.

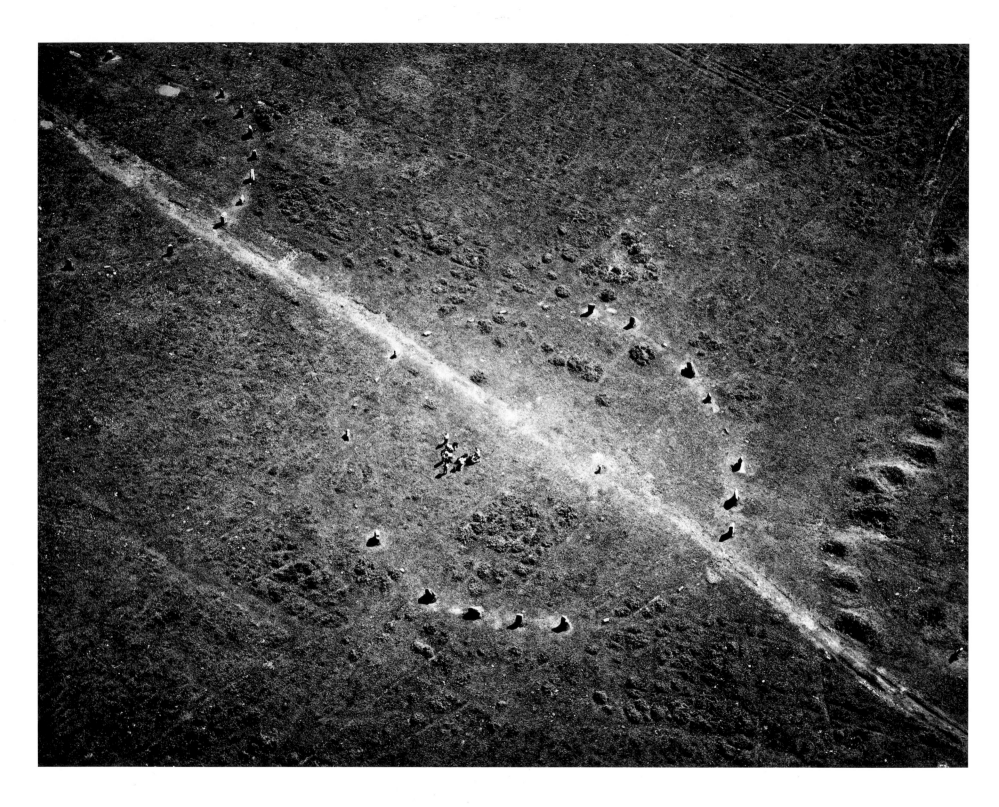

GREY WITHERS, Devon, 1985 These two stone circles, each about 100 feet
in diameter, lie in the wild landscape of Dartmoor and probably date from c. 2600–1900 B.C.
They were places where rituals took place and were used for astronomical sightings.

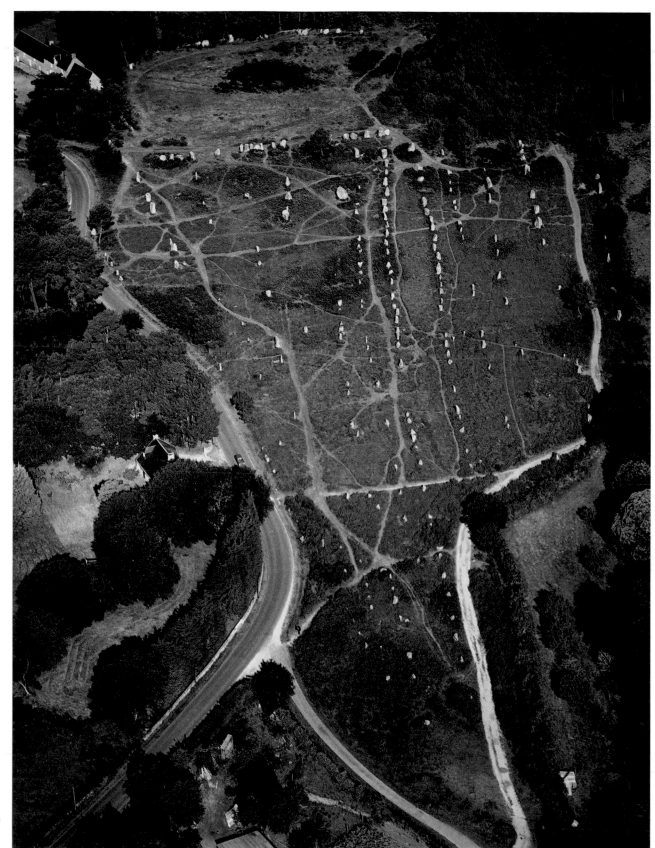

CARNAC # 1, Brittany, France, 1985
One of three stone alignments at Carnac, set
in rows with intervening avenues, runs
for almost a mile. The stones, up to 12 feet
in height, were placed by a pre-Celtic people
sometime between 2500 and 2000 B.C. It appears
they had astronomical significance perhaps
concerning lunar cycles.

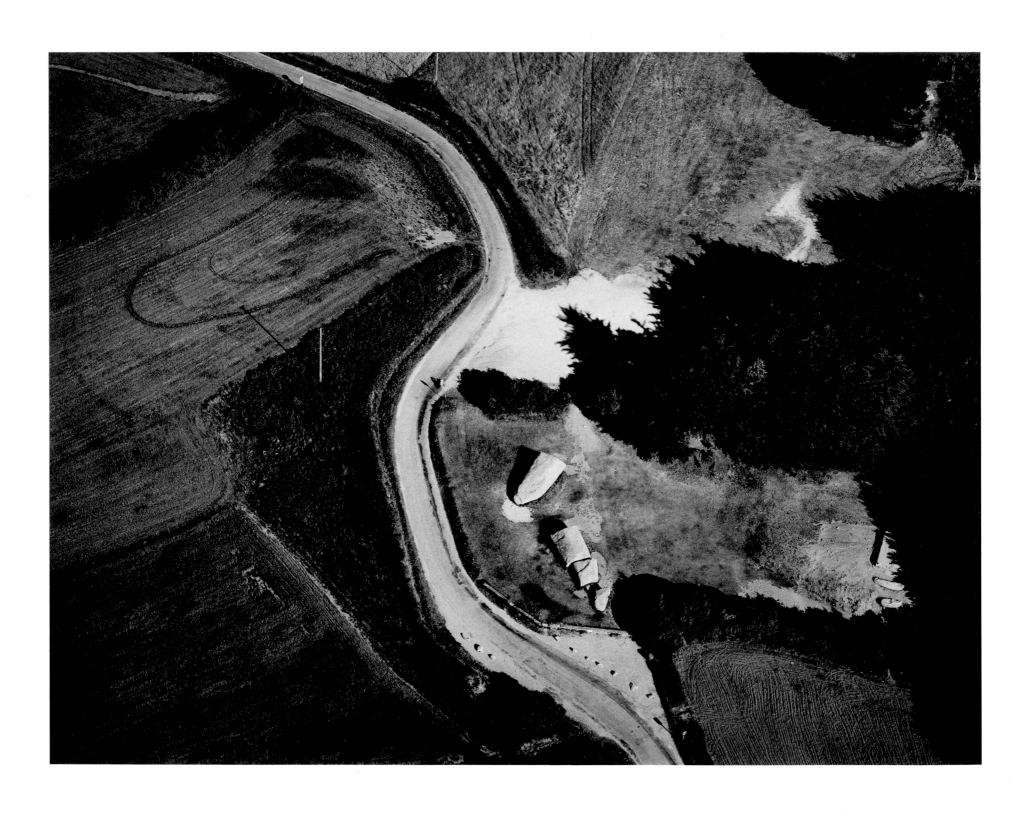

GREAT MENHIR, Carnac, Brittany, France, 1985 The Great Menhir at Locmariaquer,
six miles from Carnac, stood 60 feet tall before it was felled perhaps by lightning. Erected around
2000 B.C., it might once have been the focal point of the Carnac lunar laboratory.

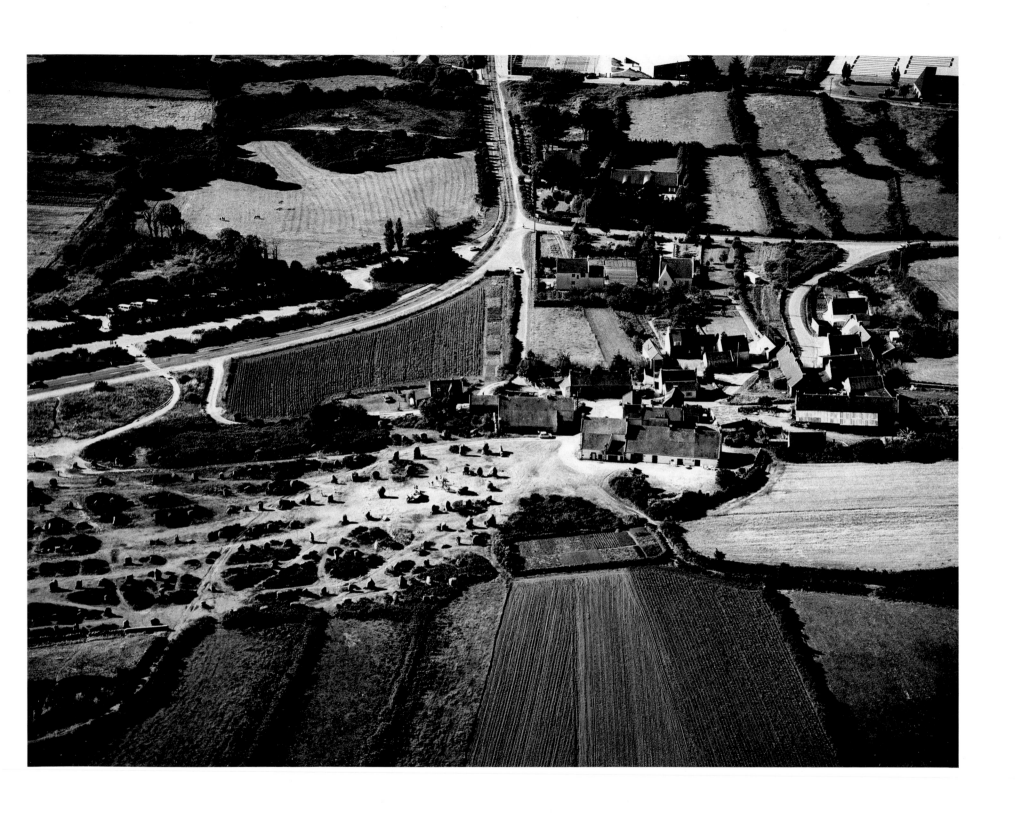

CARNAC WITH VILLAGE, Brittany, France, 1985
The alignment at Le Menec has 1,099 standing stones set in 12 rows.

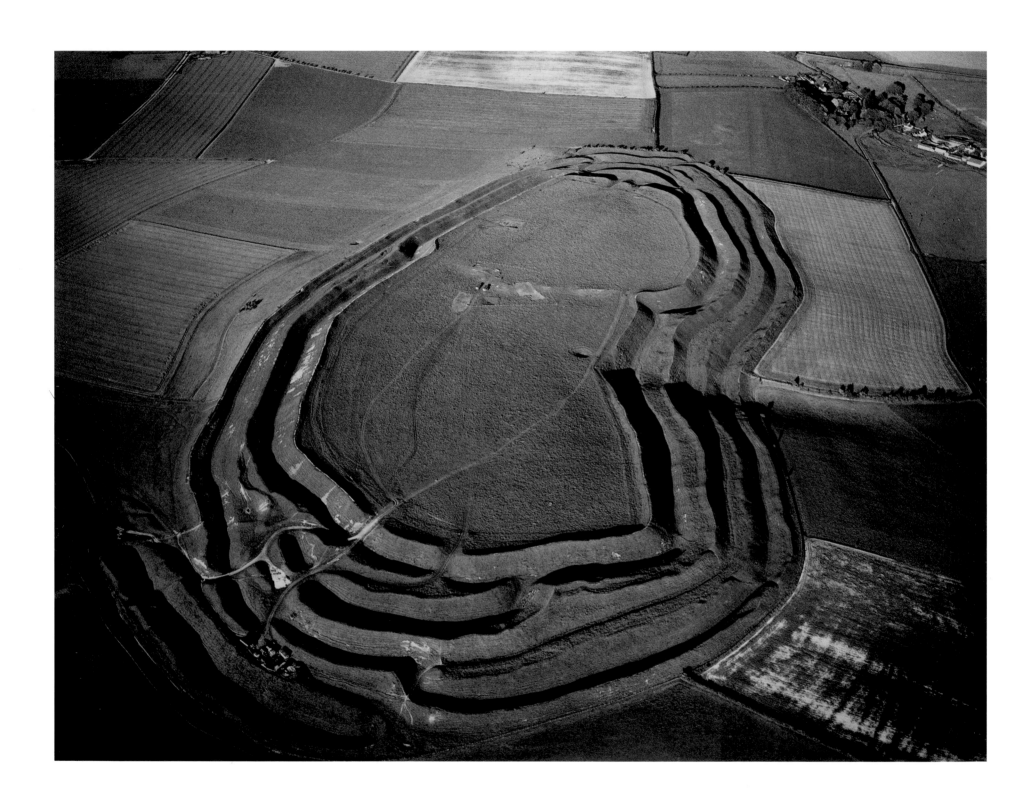

MAIDEN CASTLE, Dorset, 1985 The largest hill fort in Britain, Maiden Castle
covers an area of some 120 acres. The fort was begun in c. 350 B.C. and completed around c. 60 B.C.
Despite its elaborate ramparts, the fort was overrun by Roman legions under Vespasian in A.D. 43.

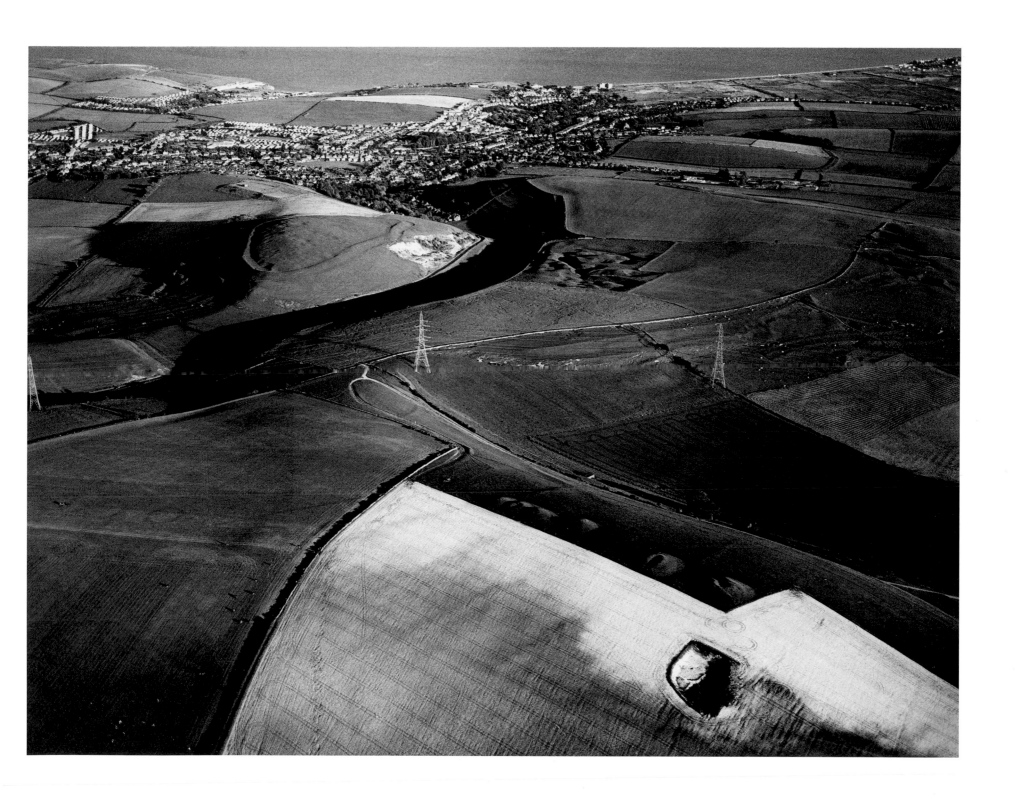

HILL FORT IN DORSET WITH PYLONS AND ROUND BARROWS, Dorset, 1985

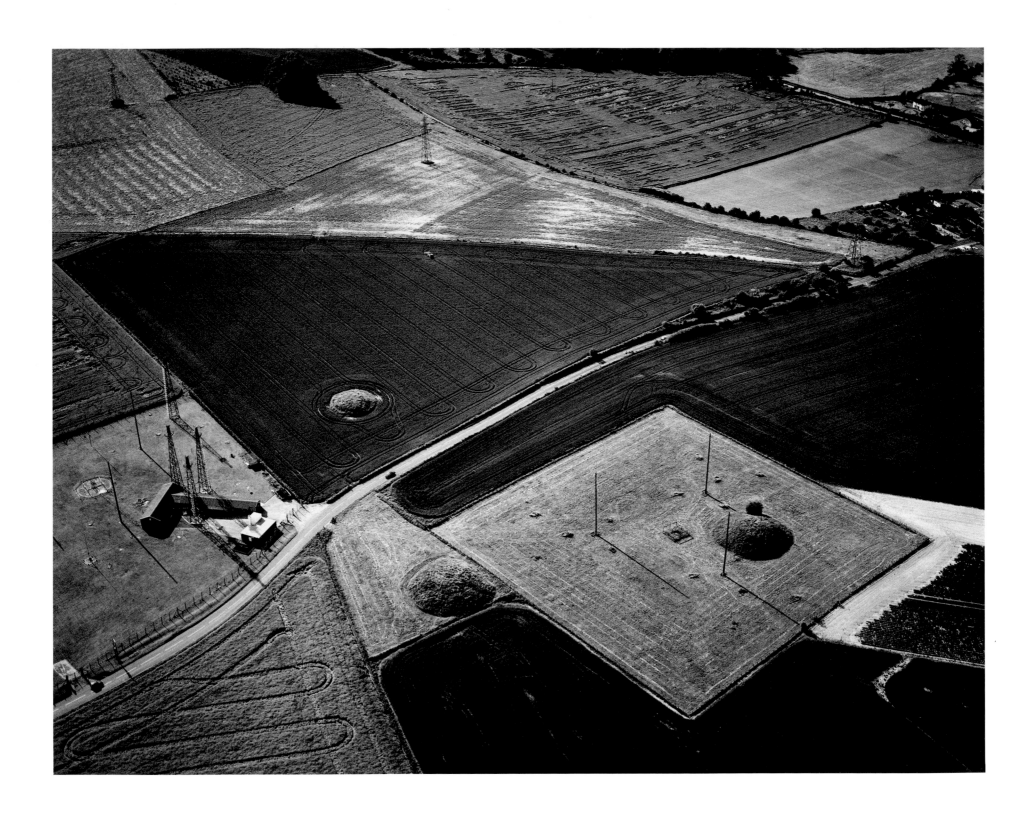

ROUND BARROWS WITH TOWERS, Wiltshire, 1985

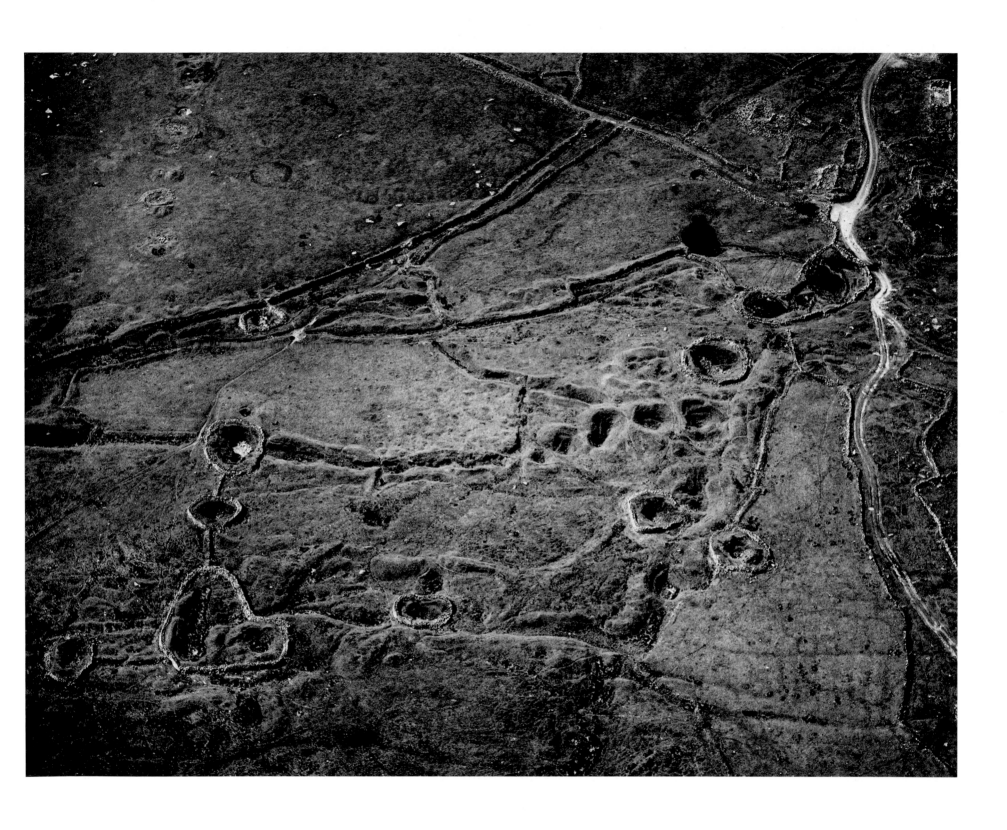

MEDIEVAL TIN MINES, West Penwith, Cornwall, 1985 Walled tops of shafts and
spoil heaps are visible.

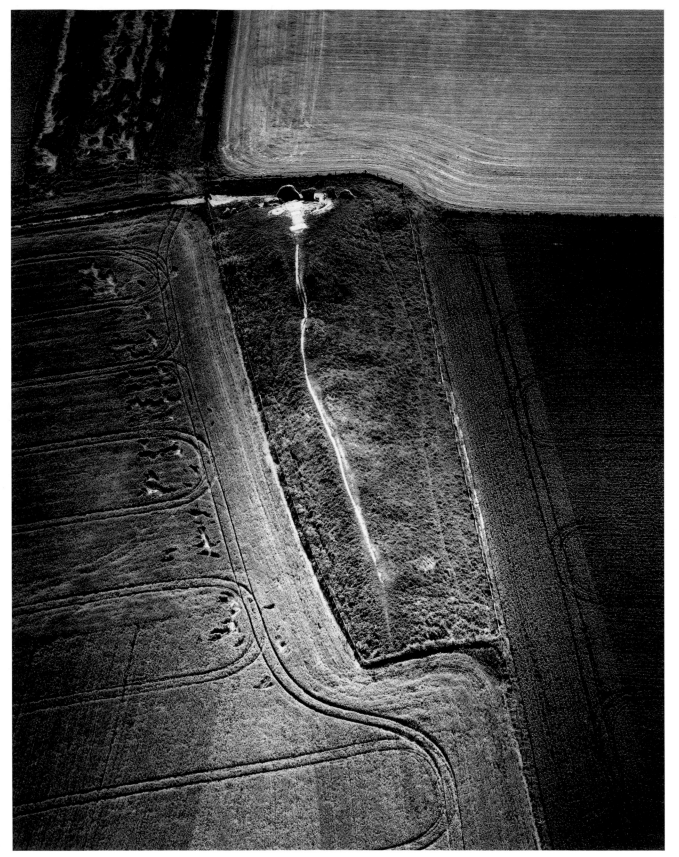

WEST KENNET LONG BARROW,
Wiltshire, 1985
This Neolithic tomb dating from c. 2500–
1900 B.C. is one of the largest in Britain.
It reaches some 320 feet in length and 8 feet
high and once held more than 40 burials.

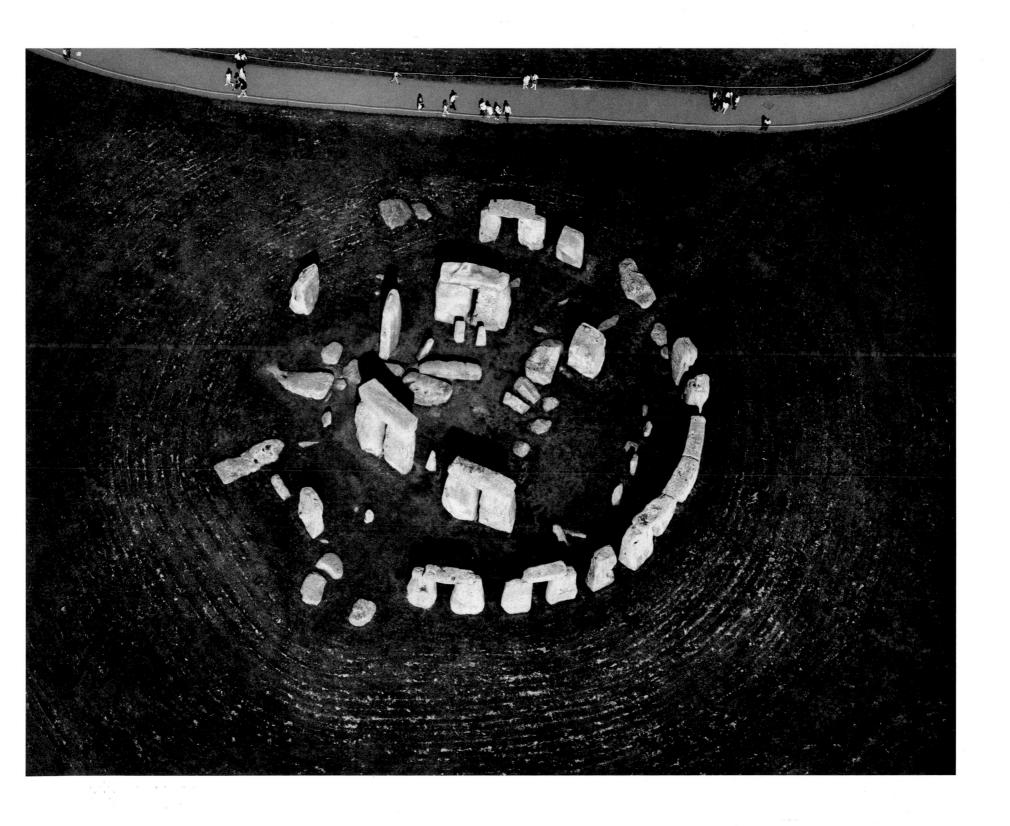

STONEHENGE # 1, Wiltshire, 1985

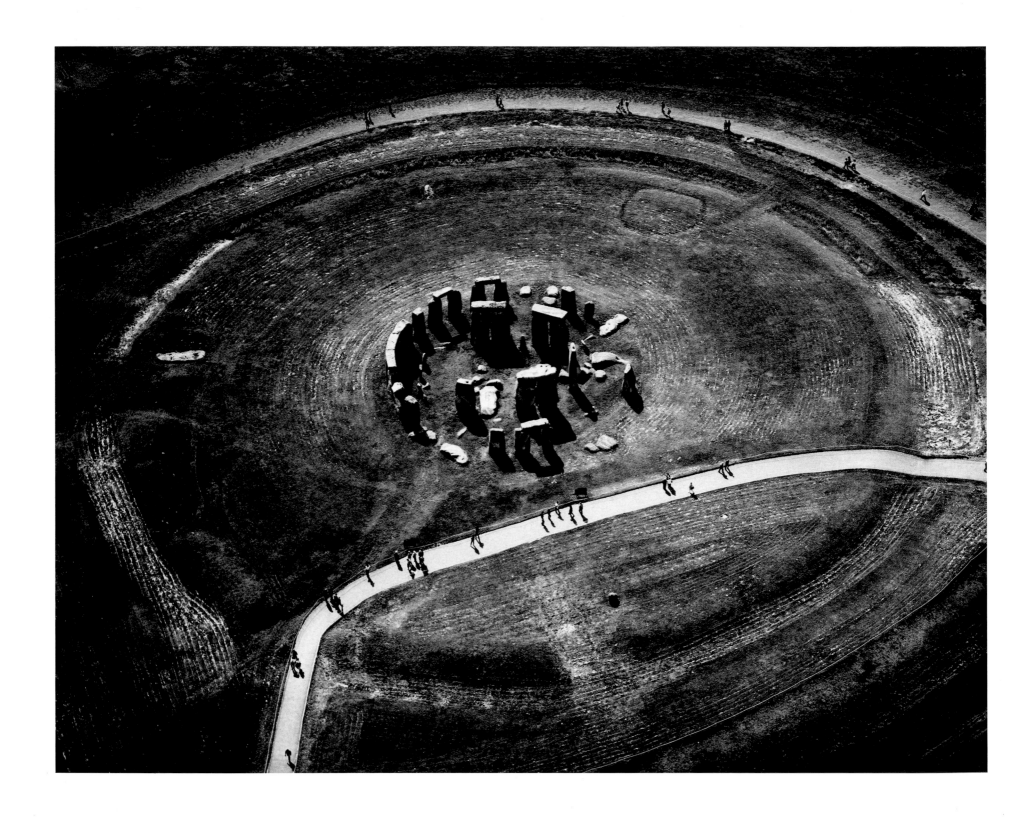

STONEHENGE # 2, Wiltshire, 1985

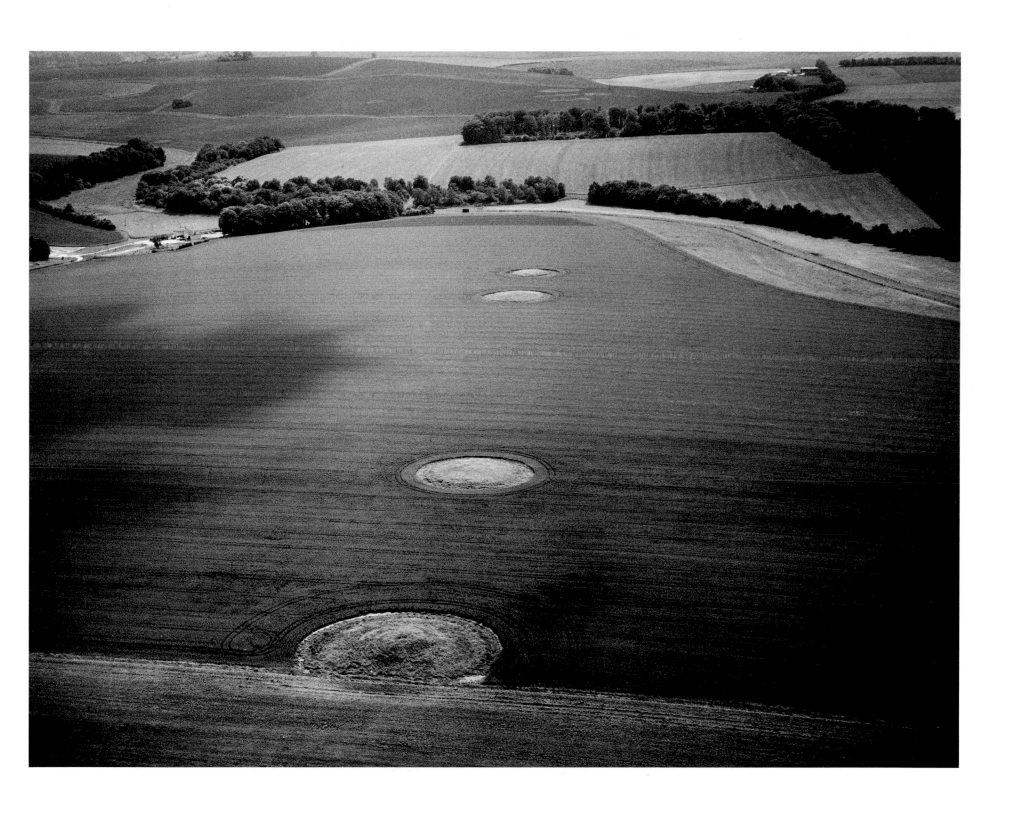

ROUND BARROWS, Wiltshire, 1985 Round barrows align with surface features to form a possible ley line.

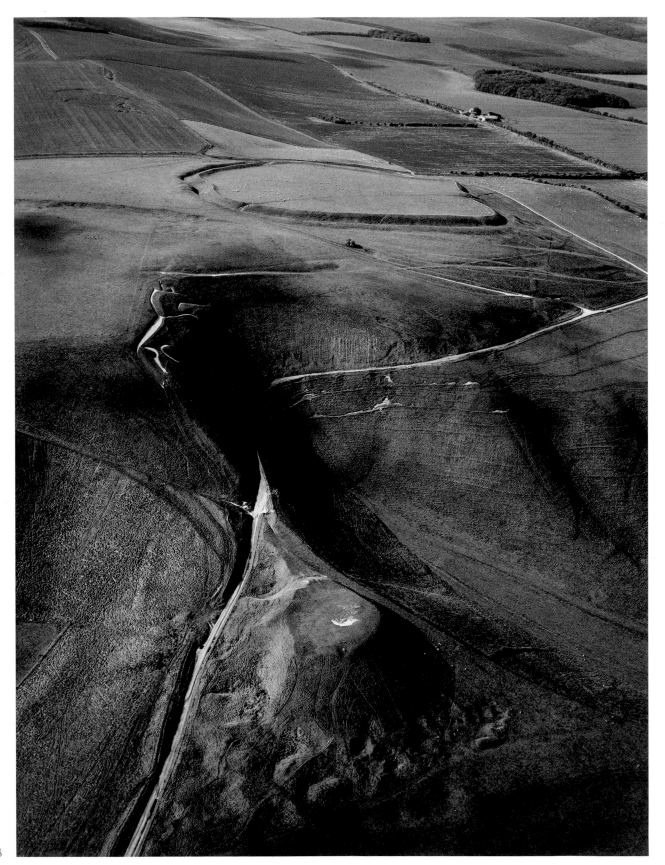

UFFINGTON HORSE, HILL FORT
AND DRAGON HILL, Oxfordshire, 1985
This magnificent creature some 365 feet long
is extended into a full gallop on Berkshire
Downs and may date to 100 B.C. The figure
was attended to by ritual scouring every
seven years during Whitsuntide. Nearby is the
hill fort of Uffington Castle, and Dragon Hill
is in the foreground.

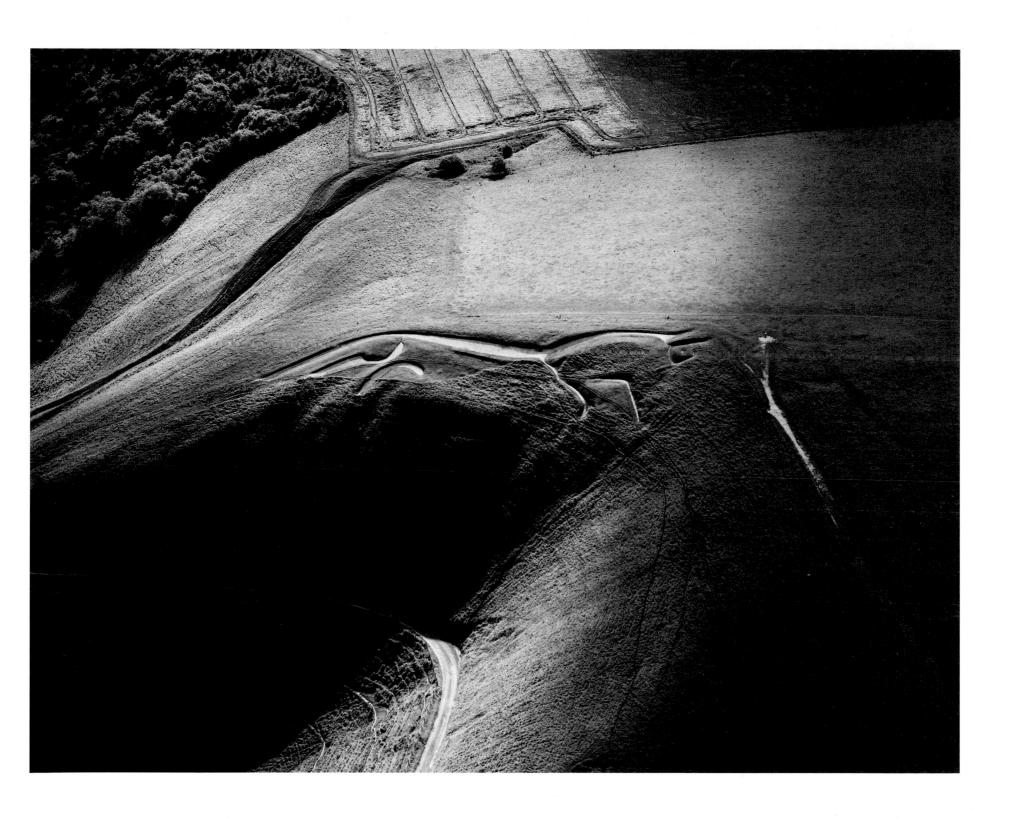

UFFINGTON HORSE, Oxfordshire, 1985

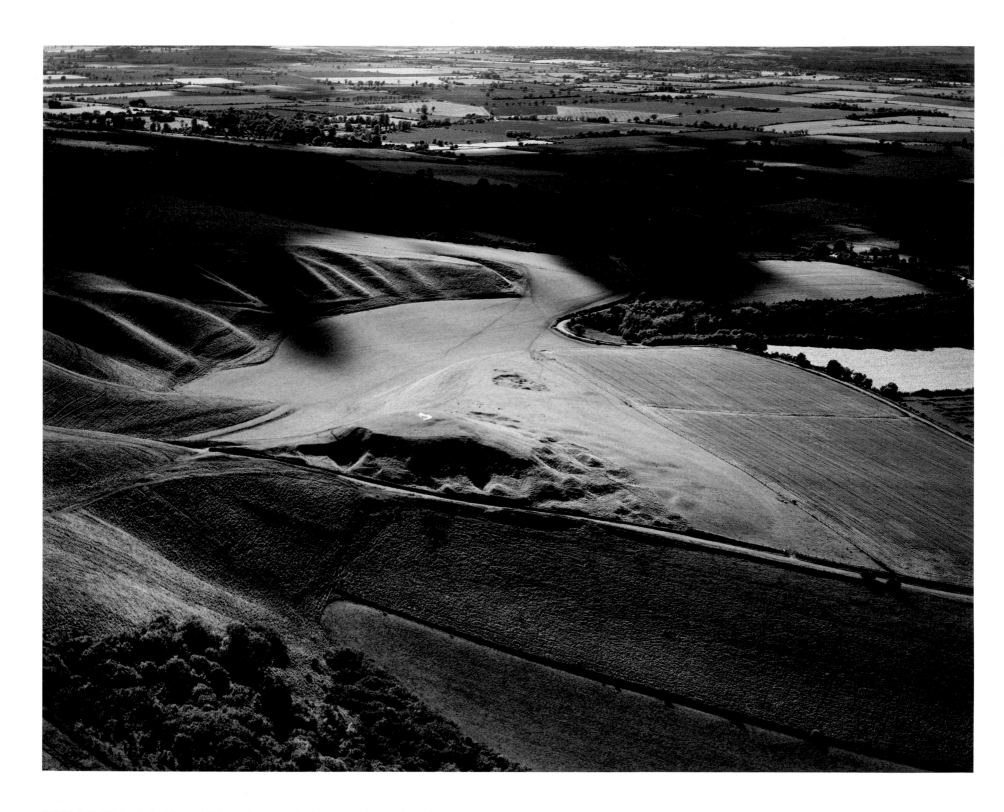

DRAGON HILL, Oxfordshire, 1985 The mound where according to legend St. George
killed the dragon is in the foreground and identified by a small spot of white on its summit. This patch of
exposed chalk "where the grass never sprouts" is said to be the spot where the dragon's blood flowed.

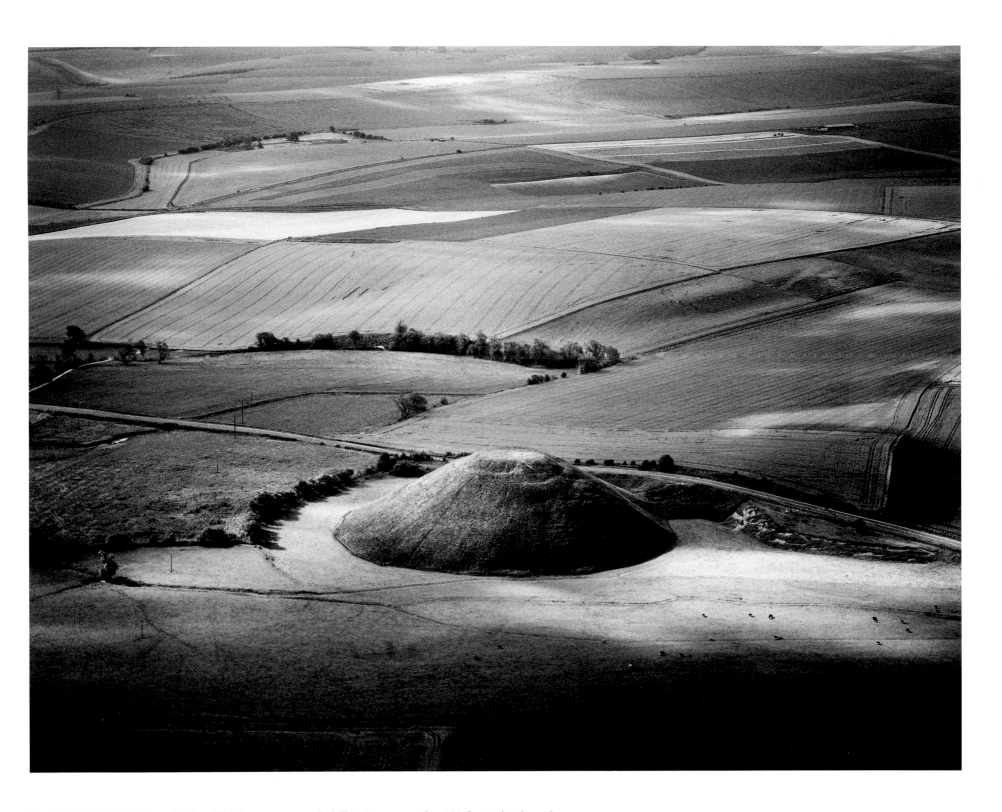

SILBURY HILL, Wiltshire, 1985 This largest man-made hill in Europe reaches 130 feet in height and covers
some 5¼ acres. Believed to have been built in four stages beginning in c. 2500 B.C., it is said to be the burial place of King Sil,
who was interned sitting on horseback. In fact, it may have served as an astronomical observatory.

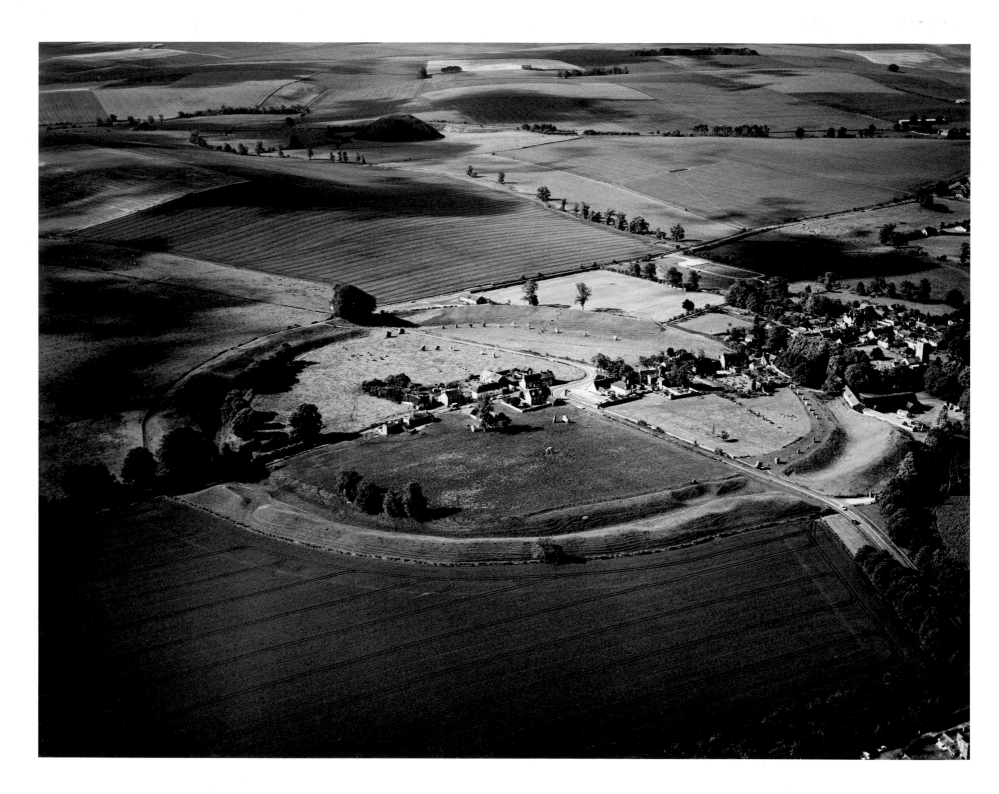

AVEBURY WITH SILBURY HILL, Wiltshire, 1985 The great earthwork and stone circles of
Avebury were probably constructed between 3000 and 1500 B.C. The outer trench and Great Circle of
stones (once numbering about 100) has a diameter of over 1,200 feet. The diameter of the inner circles
(now largely destroyed) is some 320 feet. Four entrances are now where modern roads run.

AFTERWORD

Sometimes one's search leads one back into the distant past to re-discover our legacy, the testimony of lives, of visions, of experiences—signatures on the surface of the earth. Pir Vilyat Khan

In 1976 while on assignment in Peru I remembered reading about the Nazca drawings. After a long excursion into the desert to see the lines I was very disappointed I couldn't see anything, and then someone suggested that I see them from a plane. Flying in a small plane was a totally new experience and a little frightening. I was amazed at what I saw; I felt privileged to be up there. I immediately understood that these lines were intended to be seen from above. I was drawn to the place as if I had been invited. The path was paved for me to return and photograph. I had no preconceived ideas; I worked with my intuition. Only later did I start to gather as much information as possible on what the lines had meant to various scholars. I felt as though I was in the presence of a great force, a force that provided unity, that challenged the narrow perspectives of our lives by requiring us to step back enough to view the whole. Without being conscious of the whole we abuse our earth. I realized that this view of Nazca could remind us of the limitations of our usual perspective, which is why I wanted to go back and photograph the lines and share that extraordinary view.

One of the reasons I acquired a pilot's license was the fear I felt in a small plane. I knew it was important to confront that feeling as much as I could. In 1982 after receiving a Guggenheim Fellowship, I hired a small single-engine aircraft and a pilot from Le Roy, New York, and we flew all the way to the Yucatán. We felt lost much of the time because the charts were not correct, and we had trouble with radio contact. We flew through lightning and thunderstorms, and we came close to running out of fuel and being forced to land in the jungle. I had to take over the controls at times and deal with my fear. Learning to fly enabled me to work with the aircraft as a tool, knowing just how far I could maneuver it or when it might stall or crash. I wanted the plane to be an extension of my body so that the plane, the camera, and I became one.

In the Yucatán I found another link with the past. The temples of the Maya were very mysterious, and their relationship to the landscape seemed significant. The jungle was as important to me as the pyramids. Those pyramid shapes rising above the jungle seemed to be an extraordinary demonstration of strength, of power over nature, but not necessarily of harmony. I felt cautious.

There is a lonely, scary feeling in some of my landscapes. I am not intellectually conscious of the feeling; only with the accumulation of years of photography am I aware of how I have translated my own emotions into the landscape. Maybe all people have known this fear, from primitive to modern man. The fear is probably of death. So many of these constructions of the past were made for the dead, for the next world. You can sense it at the sites, as at the Native American burial mounds. The fear, deep inside, is of something we can never be sure of. I bring up this question for all viewers of these photographs, so that they recognize the isolation. We are very much alone, just as we are all born alone and are all going to die alone. Even if we have come to terms with that isolation, once in a while it seems undeniably present.

Different sites elicit different responses. At Nazca, or at the Serpent Mound in Ohio, I felt no separation from the places. After I had visited the mound I often used to dream of flying with the serpent. The degree of separation or of blending is defined differently in each series of photographs. The contrast between modern man and the ancient society whose remains he is viewing is clear in the photograph of Stonehenge, where contemporary viewers just hang off the top of the frame of the photograph. They are on the edge.

I continue to work from the air because of the heightened awareness I obtain from this altered perspective. Flying is a passion, an addiction. I need to fly. Unlike those of photographers working from the ground, my landscapes are not arranged; they are instant decisions. I have to be very fast and completely conscious or it's gone. I don't have much time to compose, so I must be in the moment. I have to freeze what I see with emotion, so that it is more than a document. These photographs are translations of my feelings experiencing the landscape and the messages of man that remain. MARILYN BRIDGES

Copyright © 1986 Aperture Foundation, Inc. The equitable owner of the copyright is The Garden Limited; Photographs © 1986 Marilyn Bridges; Preface © 1986 Haven O'More; Essays © Maria Reiche, Charles Gallenkamp, Lucy Lippard, and Keith Critchlow; Afterword © Marilyn Bridges. Published for The Garden Limited by Aperture Foundation, Inc. All rights reserved under International and Pan-American Copyright Conventions. Composition by David E. Seham Assoc., Inc., Metuchen, New Jersey. Printed and bound in West Germany by H. Stürtz AG in Würzburg. Library of Congress Catalog Card Number: 86-071462. Hardcover ISBN: 0-89381-228-5; Paperback ISBN: 0-89381-423-7.

This book is published in cooperation with the Professional Photography Division of Eastman Kodak Company, Rochester, New York.

CREDITS: Thomas Bridges for caption research; Harry Casey and Boma Johnson for their assistance and for providing information concerning the Southwest geoglyphs; and Clark Mallam and Luther College for their help while photographing the Iowa effigy mounds. Aperture offers special thanks to Rayomond H. DeMoulin of Eastman Kodak for his guidance and support in accomplishing this new edition.

The Staff at Aperture for Markings is Michael Hoffman, Executive Director; Christopher Hudson, Vice President, Publishing; Mark Holborn, Editor; Larry Frascella, Managing Editor; Stevan Baron, Production Consultant; Annabel Levitt, Production Manager; Eileen Smith, Project Editor; Marguerite Damato, Production Assistant; George Slade, Work Scholar. Book design by Wendy Byrne.

Aperture Foundation Inc. publishes a periodical, books, and portfolios of fine photography to communicate with serious photographers everywhere. A complete catalog is available upon request. Address: 20 East 23 Street, New York, New York 10010.